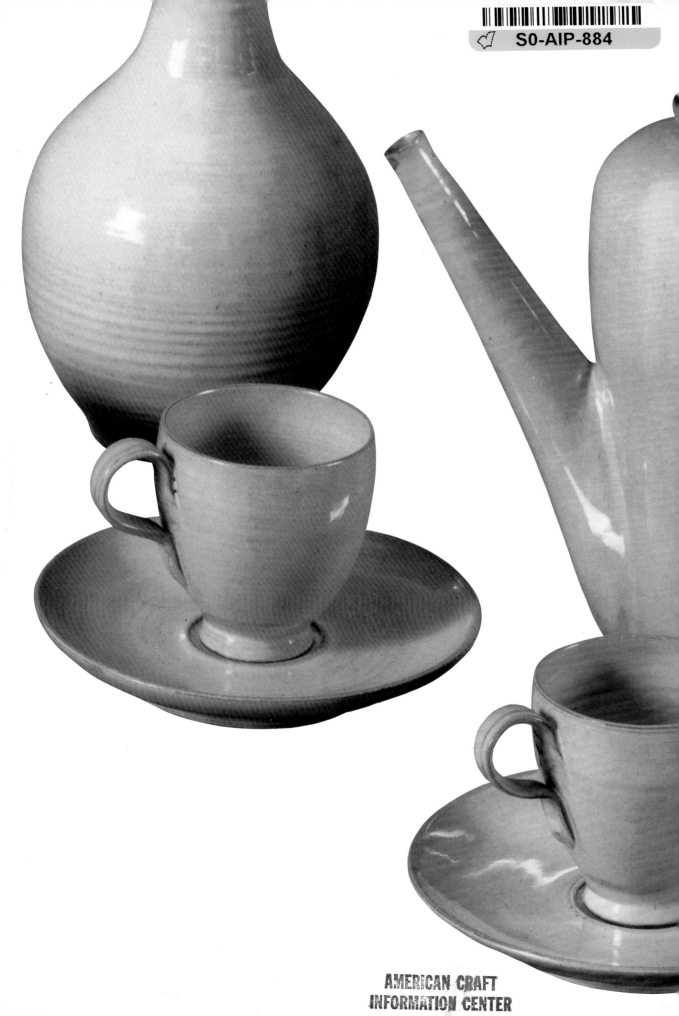

S0-AIP-884

AMERICAN CRAFT
INFORMATION CENTER

AMERICAN POTTERS:
Mary and Edwin Scheier

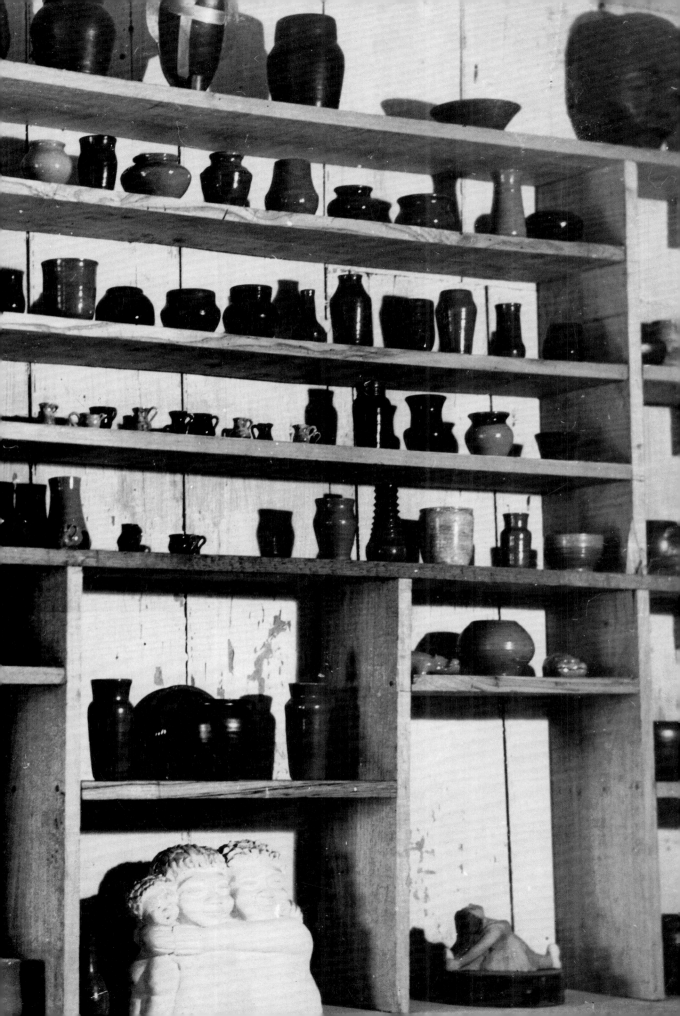

AMERICAN POTTERS:
Mary and Edwin Scheier

MICHAEL K. KOMANECKY

THE CURRIER GALLERY OF ART · MANCHESTER, NEW HAMPSHIRE

AMERICAN CRAFT
INFORMATION CENTER

NK4210
.S388 K66
1993

The Currier Gallery of Art, 1993
All rights reserved.
Library of Congress Catalog Card Number: 93-072197
ISBN 0-929710-12-6

COVER: *Vase* (detail), mid-1950s [cat. 103]

FIRST PAGE: *Carafe with Cups* and *Coffee Pot with Cups and Saucers* (details), late 1940s – early 1950s [cat. 17, 16]

FRONTISPIECE: The Scheiers' work on the shelves at Hillcrock Pottery, 1939

Contents

Lenders to the Exhibition

AMERICAN POTTERS:
Mary and Edwin Scheier

THE CURRIER GALLERY OF ART
Manchester, New Hampshire
September 19 through December 5, 1993

THE ARIZONA STATE UNIVERSITY
MUSEUM OF ART
Tempe, Arizona

This exhibition has been organized by The Currier Gallery of Art and is made possible by a grant from the National Endowment for the Arts, a federal agency. Additional funding has been provided by the Henry and Olga Wheeler Fund of The Currier Gallery of Art, the Richard A. Florsheim Art Fund, Stephane Janssen, Philip E. Aarons, Bjorg S. and Richard J. Dranitzke, Mark Isaacson, Peter S. Brams, Estate of Dr. Albert W. Grokoest, Rosamond B. Vaule, Edward D. and Polly S. Eddy, Ruth and George Wald, Betty and Francis Robinson, Mrs. Charles T. Bacon, Jean and Frank Kefferstan, the David and Barbara Stahl Fund of the New Hampshire Charitable Fund, David and Barbara Stahl, Hans and Phyllis Heilbroner, Joseph E. and Shirley Cohen, Kimon S. and Anne Zachos, and other donors.

PHILIP E. AARONS

BEATRICE H. ACHORN

THE ADDISON GALLERY OF AMERICAN ART, PHILLIPS ACADEMY

THE AMERICAN CRAFT MUSEUM

THE ART GALLERY, UNIVERSITY OF NEW HAMPSHIRE

MR. AND MRS. MEL BOBICK

PETER S. BRAMS

FLORA CAMPBELL

MARIA CARRIER

CHATHAM COLLEGE GALLERY

SHIRLEY AND JOE COHEN

THE CURRIER GALLERY OF ART

ROBERT AND NANCY DEANE

DETROIT INSTITUTE OF ART

DR. AND MRS. RICHARD DRANITZKE

MR. AND MRS. EDWARD D. EDDY

FRED AND VALERIE ENGLAND

EVERSON MUSEUM OF ART

ELENORE FREEDMAN

ESTATE OF ALBERT W. GROKOEST

KAREN HASLERUD

JOHN AND MARYANNA HATCH

MRS. JOHN A. HOGAN

MARK ISAACSON

MARION E. JAMES

STEPHANE JANSSEN

JEAN AND FRANK KEFFERSTAN

THE LEAGUE OF NEW HAMPSHIRE
CRAFTSMEN FOUNDATION

NORMAN AND ANNE MILNE

JOSEPH MULLEN AND FRANK HOWARD

NEW ORLEANS MUSEUM OF ART

MARY AND EDWIN SCHEIER

DAVID AND BARBARA STAHL

THE UNIVERSITY OF NEW HAMPSHIRE
MUSEUM

THE UNIVERSITY OF NEW HAMPSHIRE
SPECIAL COLLECTIONS

GEORGE AND RUTH WALD

GERRY WILLIAMS

ANONYMOUS LENDERS

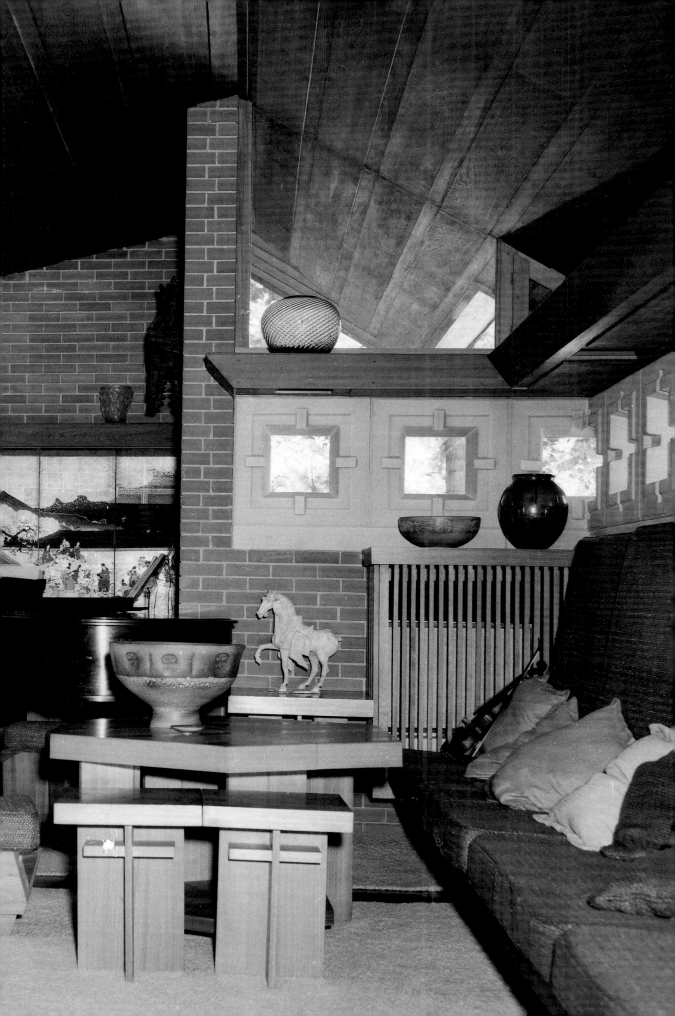

Director's Foreword

When the Zimmerman House, designed by Frank Lloyd Wright, was bequeathed to The Currier Gallery of Art in 1988, the museum acquired with it the most important collection of works by Edwin and Mary Scheier in America. Although the Scheiers had many New Hampshire patrons, Dr. Isadore J. and Lucille Zimmerman selected a particularly strong group of major works. From the year of the bequest, curator Michael Komanecky laid a plan to create the first major retrospective exhibition of the Scheiers' work, a project whose fruition we may now joyously celebrate. It is especially appropriate that this retrospective take place at the Currier and in New Hampshire, where the state's institutions – the Currier, the University of New Hampshire, and the League of New Hampshire Craftsmen – so nurtured their careers.

We are proud to announce that through a planned gift, the Scheiers will one day bequeath their art collection to The Currier Gallery of Art. At that time, the museum will inherit a remarkable group of some of America's most noteworthy twentieth-century ceramics, along with fine examples of Japanese and Chinese pottery, pre-Columbian sculpture, and objects from other cultures the Scheiers grew to admire. The Scheiers' own works – not only ceramics, but also sculptures and weavings – will take their place in the Currier's important collection of American decorative arts. As both Michael Komanecky and I have strived to expand the twentieth-century component of this collection, it is particularly satisfying to know that our goal will, one future day, be a great step further toward achievement.

The successful completion of a multi-year project such as this results from teamwork among many individuals: the artists themselves, the Currier staff, outside experts, and generous supporters and lenders. We are deeply grateful to Mary and Edwin Scheier, whose kindness and warm friendship to the Currier has made it possible for us to organize this comprehensive exhibition and to publish an American story, the story of their life and art. Second, we extend our sincere thanks to our hard-working and superb staff, particularly Michael Komanecky, whose love of and devotion to this project shines through every detail of its conception and implementation.

Many generous donors have provided support to the exhibition and catalogue. We extend our appreciation to the National Endowment for the Arts, a federal agency, and the Richard A. Florsheim Art Fund. Additional funding has been provided by the Henry and Olga Wheeler Fund of The Currier Gallery of Art, Stephane Janssen, Philip E. Aarons, Bjorg S. and Richard J. Dranitzke, Mark Isaacson, Peter S. Brams, Estate of Dr. Albert W. Grokoest, Rosamond B. Vaule, Edward D. and Polly S. Eddy, Ruth and George Wald, Betty and Francis Robinson, Mrs. Charles T. Bacon, Jean and Frank Kefferstan, The David and Barbara Stahl Fund of the New Hampshire Charitable Fund, David and Barbara Stahl, Hans and Phyllis Heilbroner, Joseph E. and Shirley Cohen, Kimon S. and Anne Zachos, and other donors.

MARILYN FRIEDMAN HOFFMAN
Director

Detail of Garden Room, c. 1955
Isadore J. and Lucille Zimmerman House, 1950
Designed by Frank Lloyd Wright
(American, 1867–1959)
Photograph courtesy of The Currier Gallery of Art

Preface

IN 1988 THE CURRIER GALLERY OF ART received what is perhaps the most significant gift in its sixty-four year history, the donation of a home designed in 1950 by famed American architect Frank Lloyd Wright for Manchester residents Isadore J. and Lucille Zimmerman. Wright designed not only this magnificent late Usonian house, but also its furniture, textiles, and gardens. The Zimmermans revelled in their new home, developing their already acute visual senses to become enthusiastic collectors of, among other things, contemporary art.

The Zimmermans had a particular passion for the pottery of Mary and Edwin Scheier, who at the time the Zimmermans moved into their home in 1952 were nationally renowned potters with works in many major American art museums. Fortunately for the Zimmermans, the Scheiers were only forty miles away at the University of New Hampshire in Durham, and sold works in local galleries as well as from their studio. Over a period of the next twenty years, the Zimmermans purchased some seventy-five pieces of Scheier pottery, forming the largest and most comprehensive private or public collection of the Scheiers' work.

While conducting research on the Zimmerman House and its contents, I became fascinated with the beauty of the Scheier pottery I encountered. Since the beginning of their careers in the late 1930s, this couple produced an astounding range of work, produced jointly as well as individually. As part of an oral history project I was directing on the Zimmerman House, I decided to visit the Scheiers in their relatively new home town of Green Valley, Arizona.

On a trip to the southwest in May 1990, I left Phoenix for the drive south of Tucson to Green Valley, the desolate but splendid desert landscape unfolding in the warmth of a late spring sun. Although I was full of questions about the Scheiers' relationship with the Zim-

mermans, I also wanted to talk with the Scheiers about the possibility of doing a show of their work at the Currier. The last major exhibition on the Scheiers was a retrospective in 1966 held at the Currier that had focused solely on Ed's work. In the intervening years since their departure from New Hampshire to Mexico, dramatic shifts in contemporary ceramics, and the simple passage of time had removed the Scheiers from public view, and to a degree diminished the esteemed positions they had held in the world of American pottery. Quite simply, this was a situation I felt should be rectified; the need to study a large body of their work was long overdue. The nationwide celebration of American craft in 1993 presented itself as the natural opportunity to pay tribute to these talented artists.

So, on that May morning, I arrived at the Scheiers' Green Valley home and studio, and was greeted warmly by Mary and Ed, now both in their eighties and ever so full of life. When I first broached the subject of a show of their work, Ed pondered my suggestion for a moment, and then replied drily in a way familiar to those who know him: "Don't wait too long." With humor, grace, and a sense of curiosity about where our adventure would lead, the Scheiers welcomed me into their home, studio, and over the next three years, into their lives.

We shared excitement for what the exhibition could be: a major retrospective of the products of a fifty-five year union of their lives and work together. During the course of several visits, Mary and Ed offered names of old friends, colleagues, and collectors who had significant examples of their work, a list that has led me to cities, towns, and villages throughout New England, and to major American art museums across the country. The Scheiers had also assembled a thorough and highly organized archive of newspaper arti-

cles, magazine articles, catalogues, and photographs of their work and lives from the 1930s to the present. This archive was an invaluable resource, and has since been donated by the Scheiers to The Currier Gallery of Art. It has been supplemented further by interviews I recorded with them in Arizona and New Hampshire.

The goal for this exhibition, and more so the book that accompanies it, is easy to articulate: to explore the work of these two American potters in context, the context of American pottery produced at mid-century; the context of American, European, and primitive art as it influenced the appearance of the Scheiers', and particularly Ed's, work; and finally, the broader context of the rich life experiences of these two remarkable people. Certain technical aspects such as glazing formulas have been given less emphasis than they might have, partially because the Scheiers have kept few records of these matters, but also because the focus here is more on the result of their technical skills rather than on the detailed methods by which they obtained them. Finally, although many American art museums collected the Scheiers' works from the 1940s on, the exhibition has been selected almost entirely from works in private hands. Owing to the enormous popularity of the Scheiers' work among their friends, neighbors, and colleagues, and of course serious collectors in New England, many of the Scheiers' best works remain in private hands. Moreover, these works have rarely if ever been exhibited.

The Scheiers' work has been published and illustrated frequently in newspapers, periodicals, books, and other publications, almost all of which are available in the Scheier archive. Understandably, numerous errors either biographical in nature or in dating their work have appeared, sometimes aided and abetted by Ed's prankish sense of humor. Called on again

and again to grant interviews, and unfailingly cooperative in agreeing to them, Ed would feel obligated to give each reporter something new to write about. On one occasion, he told a reporter a story about having an interest in tattoos and tattooing – a complete fabrication – and this story has persisted, even in print, for some forty years. While correcting errors, I am hopeful, too, that I have not been taken in by one of Ed's practical jokes. As he related in one of the last interviews I conducted with Mary and Ed, "The best memories we have are of things that never happened."

Many people have contributed to make this presentation of the Scheiers' lives and work possible. Foremost among them are private individuals and museums who have lent their valued possessions, and the foundations as well as private donors who have made financial contributions to help underwrite the project. Over the past four years, my research has been aided by potters, dealers, and scholars of American ceramics, including Maria Graubart, Mark Isaacson, Ronald Kuchta, Otto Natzler, Paul Smith, and Gerry Williams. Former Currier intern Sean Moynihan deserves special mention for organizing the Scheier archival materials. Also at the Currier, Marilyn Hoffman, Virginia H. Eshoo, and Maria Graubart, and Rosalie Reed all offered useful comments on my manuscript, and editor Linda Landis provided expert advice as well. Several museum staff members made equally valuable contributions to organizing the exhibition, including registrar Ellie Vuilleumier, curatorial assistant Darlene Antonellis-LaCroix, preparator Timothy A. Johnson, and the installation crew of Al Grimard, Ronald Sklutas, and Steven Lis. Gilbert Design Associates designed this handsome catalogue, and Betsy Bailey of Graphic/ Graphics Design is responsible for the striking installation design. Rosalie Reed deserves special mention, too, for her many contributions throughout this project. To all of these people, and many others not mentioned, I am deeply grateful; it has been an exciting collaboration.

In an artistic and a personal sense one of the most significant aspects of the Scheiers' work,

of course, is the degree to which they have collaborated so fully, fruitfully, and festively over the past five decades. The Scheiers' deep commitment to being jointly involved in the act of creation remains one of their most remarkable qualities. Since the early 1980s, arthritis has prevented Mary from working her magic on the wheel. Regardless, Ed continues to describe his new works as something "we" – Mary and he – have done, even though they are entirely of his hand. The true value of Mary and Ed Scheier's contributions resides not just in the objects of clay, stone, wood, or fabric fashioned by their hands, but also in their unconditional embrace of their lives together as friends and companions, as consummate artists, and as devoted husband and wife. It is to this extraordinary union that this book is dedicated.

MICHAEL K. KOMANECKY
Curator, The Currier Gallery of Art
June 12, 1993

Color Plates

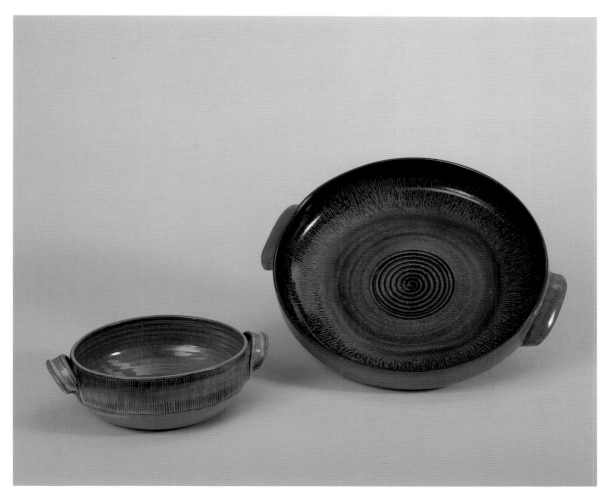

Casserole, early 1950s [CAT. 23] *Casserole*, late 1940s – early 1950s [CAT. 22]

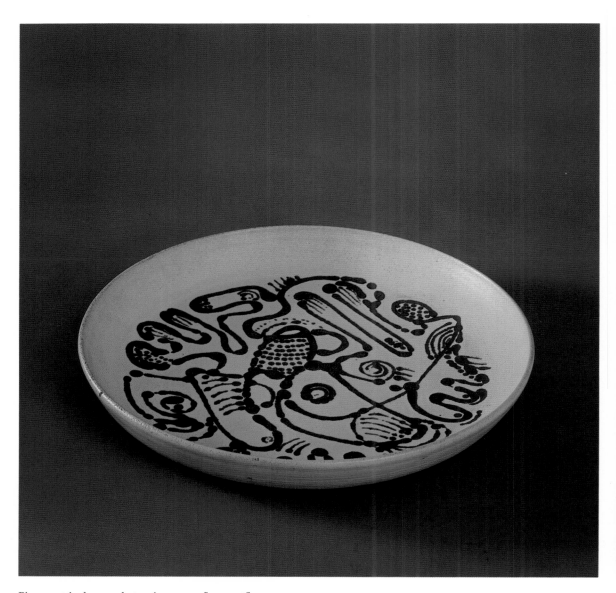

Platter with abstract design, late 1940s [CAT. 46]

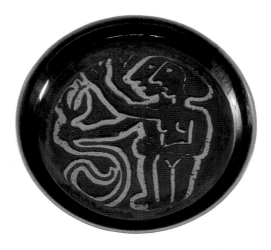

Platter with the Temptation of Adam and Eve,
c. 1948 [cat. 50]

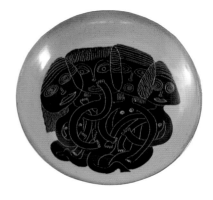

Platter with Figures, 1947 [cat. 53]

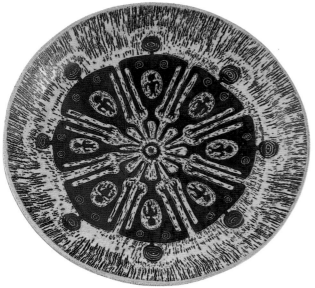

Platter with abstract figure design, late 1940s –
early 1950s [cat. 57]

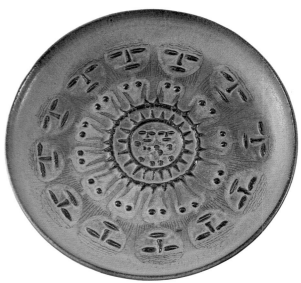

Platter with abstract figure design, late
1940s – early 1950s [cat. 58]

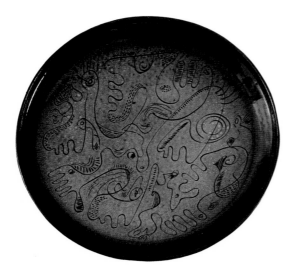

Platter with abstract head design, late 1940s – early 1950s 〖CAT. 59〗

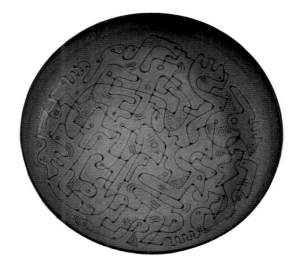

Platter with abstract design, c. 1948 〖CAT. 60〗

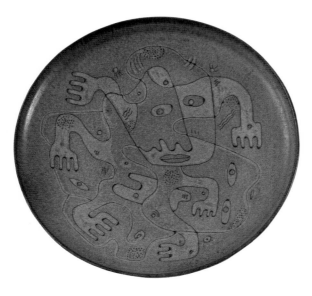

Platter with abstract figure design, late 1940s – early 1950s 〖CAT. 61〗

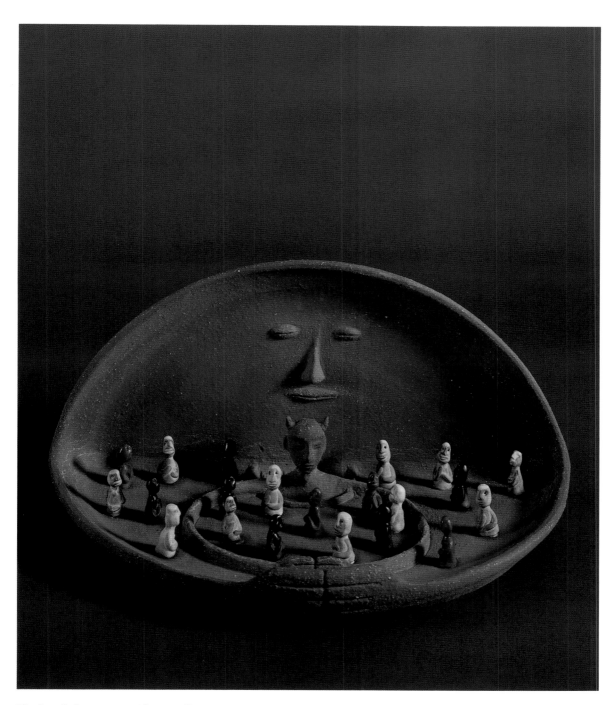

The Last Judgement, 1946 〚CAT. 74〛

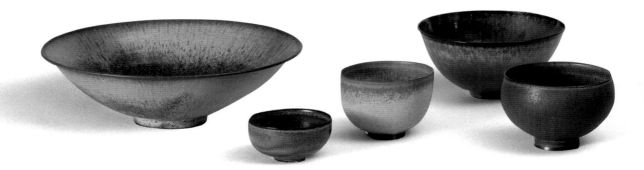

Bowls, late 1940s – early 1950s [CAT. 29, 34, 36, 30, 32]

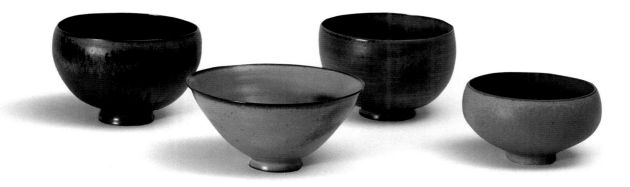

Bowls, 1950s [CAT. 26, 28, 27, 31]

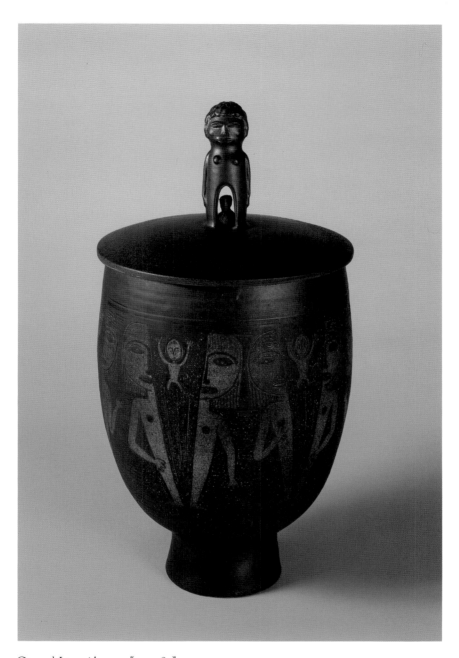

Covered Jar, mid-1950s [CAT. 84]

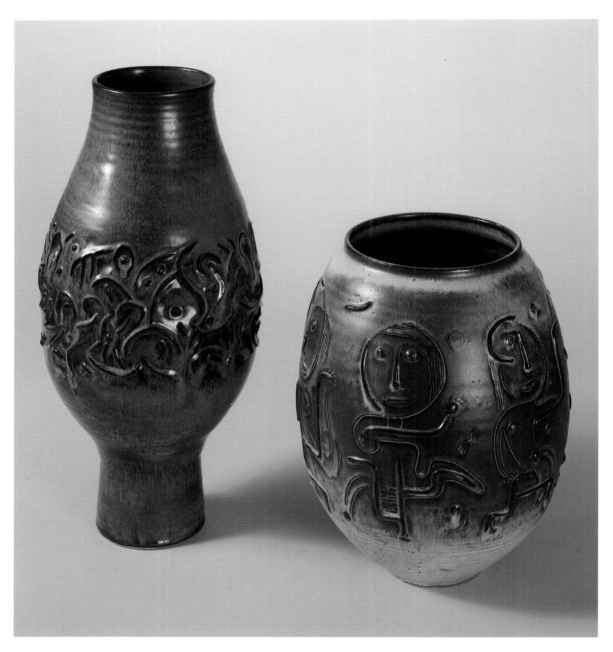

Vase with abstract design, early 1960s 〖CAT. 90〗 *Vase with figure decoration, mid-1950s* 〖CAT. 89〗

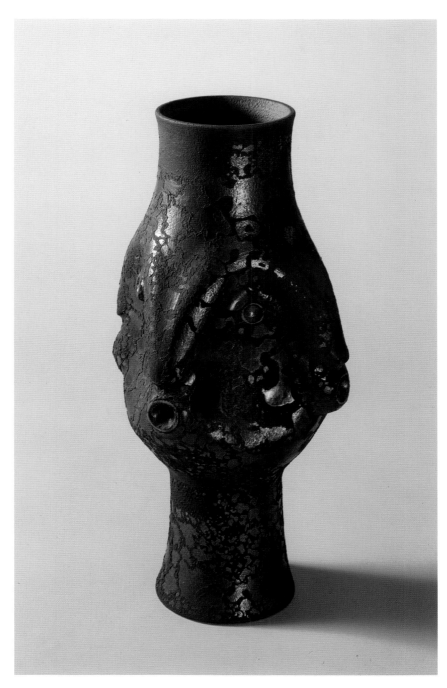

Vase with face design, 1966 ⟦CAT. 109⟧

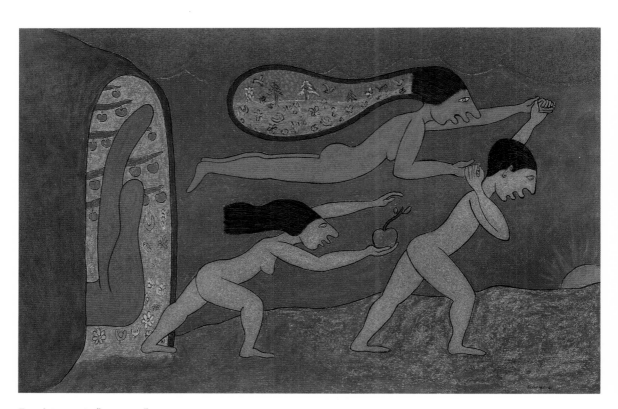

Expulsion, 1960 〚CAT. 154〛

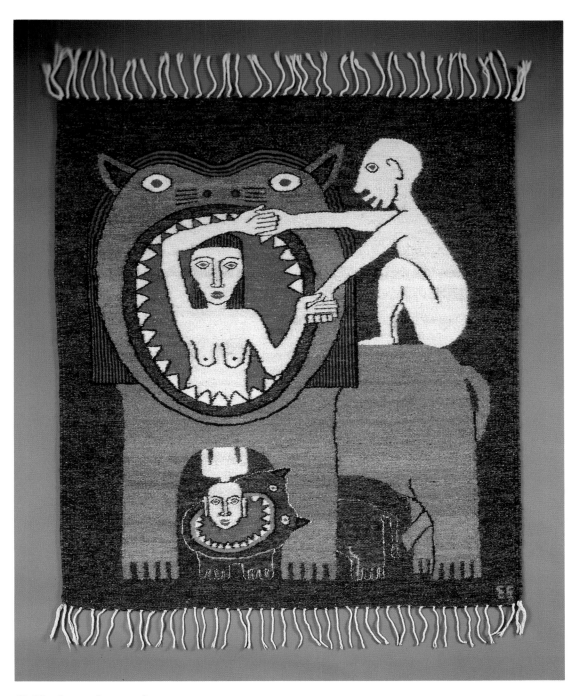

Childbirth, 1974 [CAT. 171]

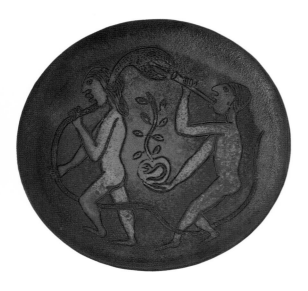

Platter with the Temptation of Adam and Eve, 1991 [CAT. 117]

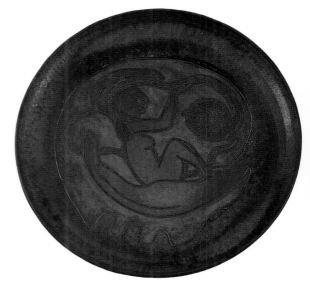

Platter with the Temptation of Adam and Eve, 1991 [CAT. 118]

Platter with the Temptation of Adam and Eve, 1991 [CAT. 119]

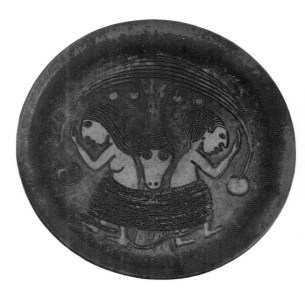

Platter with the Temptation of Adam and Eve, 1991 [CAT. 120]

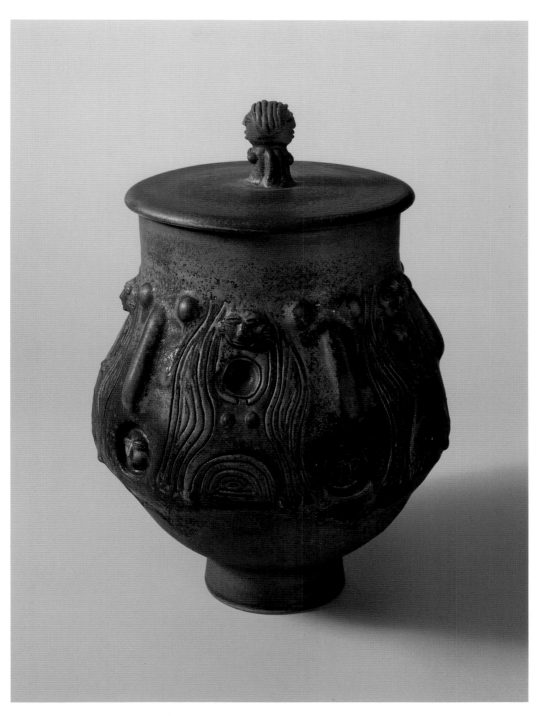

Covered jar with figure and face design, 1993
⟦CAT. 139⟧

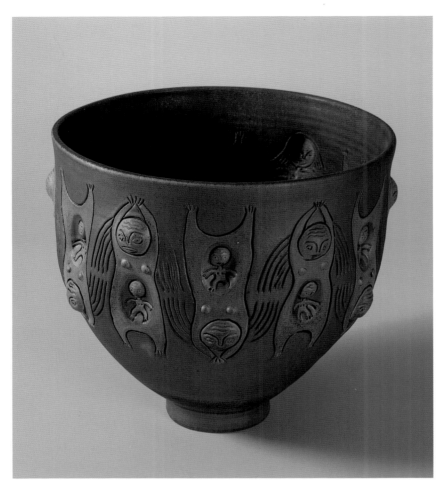

Bowl with figure design, 1991 ⟦CAT. 131⟧

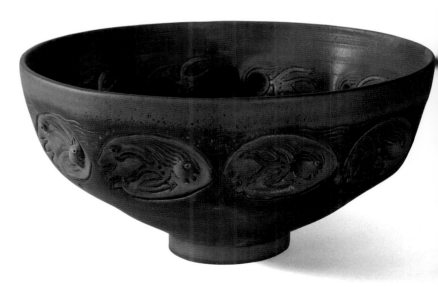

Bowl with figure design, 1992 ⟦CAT. 136⟧

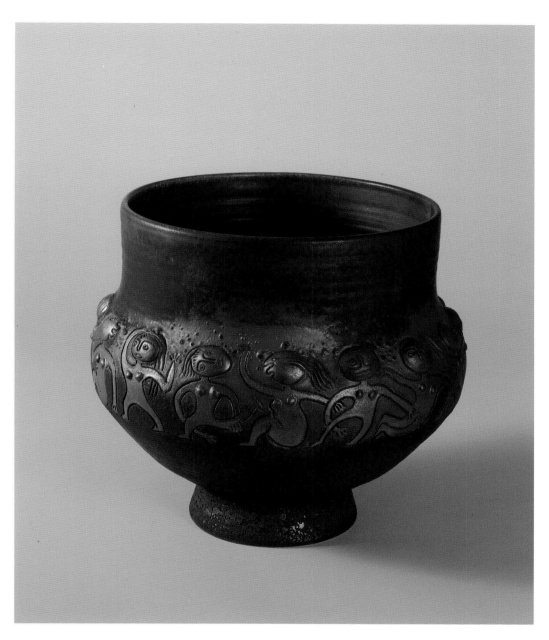

Bowl with figure design, 1993 〚CAT. 128〛

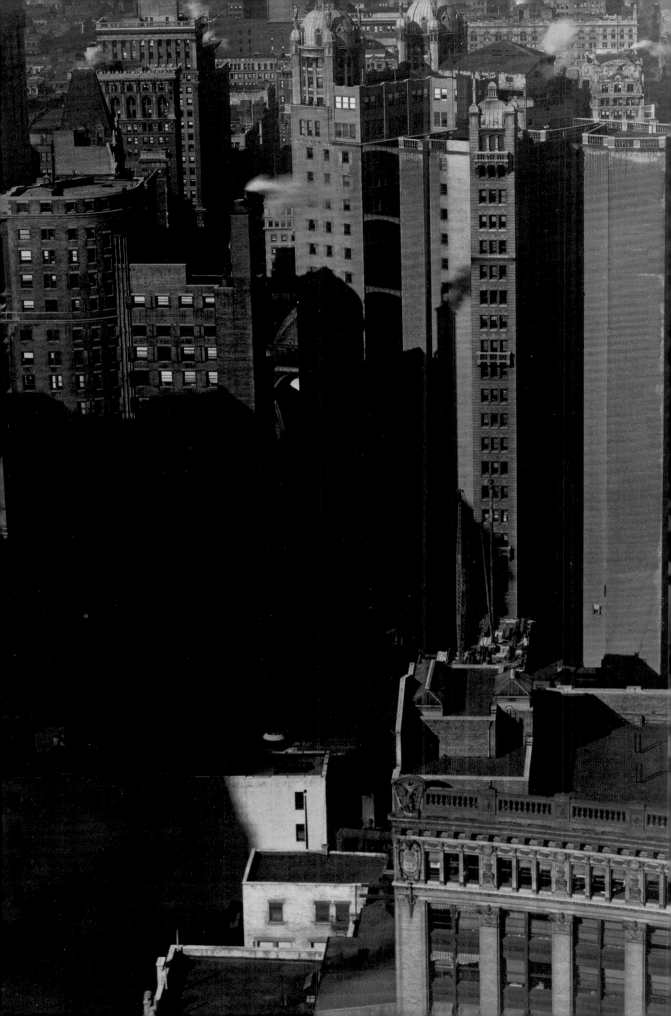

CHAPTER ONE: *Beginnings*

"*Courage doesn't have anything to do with
becoming an artist. It's just something you want
to do. I think it's inside you.*"[1]

Mary Scheier

"*It is much better not always to know too
much and to be lucky. Luck is one of the great
elements in a person's life. I think in a way
it is how we have stumbled into one or another
situation through luck that has helped us
advance.*"[2]

Edwin Scheier

FROM VERY DIFFERENT BEGINNINGS, Mary
and Ed Scheier each followed a path that would
lead them to discover, explore, and, over the
course of a half-century devoted to making pot-
tery, greatly refine their creative powers. In
retrospect their paths seem clear and if not
direct, then at least with few serious or
lengthy diversions. Yet at the time they set out
on their individual journeys, life presented itself
with anything but clarity. The Scheiers were
both born in the first decade of this century
and, as children, experienced the United States'
entrance into the Great War. Their adoles-
cence took place during the unbridled optimism
of the 1920s, while adulthood brought them
face to face with the unparalleled economic hard-
ships of the Great Depression. They matured
as artists and established their reputations just
as the country entered a second global war.
These political and economic forces, perhaps
even more than esthetic ones, shaped their
artistic characters. Their lives consisted of far
more than mere survival, of course, and in their
achievements as two of America's finest studio
potters of the twentieth century, both luck

and inner guidance, in addition to talent and
creativity, played significant roles.

Mary Skinker Goldsmith was born on May 9,
1908, in Salem, Virginia, a small town in the
Blue Ridge Mountains some ten miles west of
Roanoke. She was the seventh child and
youngest daughter in a family of nine children,
five girls and four boys. Her father, James
Skinker Goldsmith, and her mother, Mira
Livingston Hamersley, were native Virginians
whose English families emigrated there in the
seventeenth century. Mary grew up in an
atmosphere of relative middle-class comfort.
Mira Goldsmith, a music teacher until mar-
riage, raised this large family, and as a result of
James Goldsmith's successful career as an
express agent for the Norfolk and Western
Railroad, all nine children attended college.[3]

Mary graduated from Salem High School in
1924, but was not yet ready to decide what
kind of career to pursue. She recalls afternoons
when she would sit in the drugstore chatting
idly with friends. "Those were wasted after-
noons. I can remember after a while thinking
'This is not the way I want to spend my life.
There has to be something more interesting.'
Not in those words, but I felt dissatisfaction."[4]
At this point, Mary's exposure to the visual
arts had consisted mostly of seeing reproduc-
tions in books and magazines around her house;
Rubens was one of the first artists whose works
she admired. Some inspiration was no doubt
provided by her mother's sister, an attorney in
a New York law firm. This aunt vacationed in
Salem every summer, and from time to time
Mary would stay with her at her Greenwich
Village apartment. Through her aunt, Mary
met a number of artists who invited her to
accompany them to New York art museums.
Mary also had an older sister who lived in
New York, with whom she also stayed from
time to time.[5]

New York and its art world attracted Mary

FIG. 1. Charles Sheeler (American, 1883–1965)
New York, Towards the Woolworth Building, c. 1920
Photograph courtesy of the Museum of Fine Arts,
Boston, Lane Collection

Goldsmith and in 1926, at the age of eighteen, she moved there. She began her studies by taking painting and drawing courses at the Grand Central School of Art, where one of her teachers was the Armenian-born painter Arshile Gorky, himself a previous student at the school who had just obtained his teaching position. Mary recalls hearing lectures by Robert Henri, painter and author of *The Art Spirit*, and an influential teacher to many young American artists grappling with modernism's initial arrival in the famed 1913 Armory Show. Like most art students in New York, she visited The Metropolitan Museum of Art. "My first trip to the Metropolitan was to make copies, as part of my training. One of the first things I painted was a picture of a suit of armor on a horse!"[6]

Seeking to expand her knowledge and to develop her abilities further, she also took courses at the Art Students League. The exciting developments in contemporary art to which she was being exposed for the first time inspired Mary to explore some of New York's galleries, including Alfred Stieglitz's Little Galleries of the Photo-Secession, known familiarly as 291 by virtue of its address on Fifth Avenue. Stieglitz was not only a talented photographer but an inveterate supporter of some of the most daring and progressive artists of his time: Matisse, Picasso, Brancusi, Braque and Picabia among the Europeans; and Marin, Hartley, Weber, Dove, and O'Keeffe among the Americans.[7]

Mary found these experiences in New York stimulating, but she also felt a need to shift directions in her studies. She decided in 1928 to attend the New York School of Fine and Applied Arts "to learn something practical, because I had to support myself." One of the school's advantages was that it offered a program abroad, and in 1930 Mary spent a year in Paris. In addition to taking courses in painting and drawing, developing her skill as a watercolorist, Mary visited the art museums in Paris frequently. Often her visits were in conjunction with course assignments to make copies of old master paintings; she thus came to admire

the work of both Delacroix and Ingres. Her contact with contemporary art was minimal, except for occasionally seeing Picasso at Paris cafes. In contrast to her experiences in New York, Mary did not venture into the galleries where the newest art was being shown.

After her year abroad, Mary returned to Virginia for several months, but eager for the excitement of New York, however, she moved back there in 1931. Despite the onset of the Great Depression, she found a job in the advertising department of a real estate agency, although she still hoped to find a way to make a living as an artist.

Mary nourished her growing passion for art by continuing to visit museums and galleries. One day while at the Metropolitan Museum of Art, she was looking intently at a case filled with ancient Chinese red vases. Unknown to her, a young man, just as intent in his examination of the Chinese pottery, was walking around the case from the other direction. Mutually immersed in their observations, they bumped into each other and struck up a conversation; the young man was Edwin Scheier.

Ed's appearance at the Metropolitan in some respects involved a simpler journey than that of Mary. Born in the Bronx, he had spent most of his life in New York. As a young boy, he discovered the Met on his own. "My first visit to the Metropolitan was overwhelming...I was interested in the armor. That was wonderful, that whole hall, especially the armor for horses."[8] Yet the visit was memorable for other reasons. "I had just become a Boy Scout, and we were going to Bear Mountain for a picnic and an overnight. I had a frying pan and a hatchet and a bag full of potatoes, and we were to meet at 86th Street. Well, somehow I missed them, and I wandered around and found this museum and went in. The museum guards were a little apprehensive. One of them followed me all over the place."[9]

His impish sense of humor adds zest to the many stories Ed tells of his life – a colorful, exotic, and often difficult life, particularly in his early years. His parents, Clara Bachert and Emmanuel Scheier, were born and educated in

Germany, and met after having immigrated to the United States in the early 1880s. They were married in 1885 and became American citizens. Their first child, Helen, was born in 1906; Ed, their second and last, was born on November 11, 1910. Although the family was Jewish, there was little if any emphasis on religious practice.

His father died shortly after Ed was born, leaving the family in a difficult if not desperate situation. "Things were very, very hard for my mother. At that time, women didn't work, and my uncle supported us. We were poor. Not only poor, but dominated by a strict Prussian-type uncle."[10] Ed's uncle Albert, a lawyer for whom his father worked as a salesman in the uncle's importing business, lived on the same street. This colorful and successful uncle had a farm: "He raised chickens and ducks, right among the apartment buildings. When the roosters crowed," Ed reminisces, "people used to throw down old shoes and things, and one of my tasks was to gather this stuff and separate it into piles of things I could sell at the junk shop."[11]

His mother married again when Ed was six but the family's situation did not improve since they soon discovered that the new head of the family was addicted to gambling. His stepfather was for a while manager of a small hat and clothing store, but like other gamblers, "He used not only his own money, but when the urge was on, he would lose the company's money. We would have to scurry around and find money," Ed recalls, "and the relatives would pool together to get him out of hock."[12]

Ed's extended family helped keep things together and provided Ed with a sense, too, that there were opportunities in life. "There was a sort of romantic streak in our family. We were very poor, but we had glamorous relatives. One of my mother's relatives became one of the most famous opera singers in New York – Claire Louise Kellogg. Her husband was an impresario and also a chemist who invented a kind of fireproof wood that he sold to the British navy for a million dollars. We also had relatives who were very wealthy, the Strausses

[the New York retailing merchants]. My uncle worked for the Strausses...at one time he was secretary to one of the Strausses, Nathan Strauss, who was ambassador to Turkey, and a great philanthropist. My uncle's task was to give away money. He gave us money, two dollars a week. So there was also this other side of the family that somehow suggested the possibilities of what one might do."[13]

Under these difficult economic and family circumstances, it is easy to understand why Ed's formal education was not foremost in his mind. He attended grammar school, but soon after graduating went to work. He was a delivery boy for a chain restaurant in Manhattan, occasionally bringing sandwiches to the Art Students League. He also worked for a while in a factory, assembling electrical equipment. "In order to get work, there was a law in New York that if you were under sixteen you had to go to what was called 'continuation school' one afternoon a week until you were sixteen. I went to a school in Harlem to study auto mechanics, but nobody there took it seriously. There were all these really tough young kids who would get under the car and shoot dice. Nobody expected you to learn anything, you were just fulfilling a requirement so your employer wouldn't have to fire you."[14]

"I worked in factories but I didn't think of it as a terrible hardship. It was just interesting. This was before the Depression, and there were lots of jobs of this sort – menial work that they would use a kid for."[15] Ed also traveled in his search for work. "I went across to the West Coast a couple of times, bumming and hitchhiking, when I was fourteen or fifteen. I was pretty much on my own. I got a job on a boat, went through the Panama Canal, up to New Orleans. But that was not uncommon. At that time there were all sorts of jobs you could pick up along the way."[16]

New York, however, remained his home. For a while, he worked at the Blue Kitchen, a modest restaurant in the financial district. One of his pals there was another delivery boy named Jacob Kainen, who later became a well-known painter and printmaker. Kainen, whom

Ed remembers as a talented prizefighter, was taking art courses at the Art Students League. Both he and Ed lived in Greenwich Village, and Kainen occasionally introduced him to artists and poets.[17] This initial and unintentional exposure to the art world gradually led Ed to a growing interest in making things with his hands. When Ed was about nineteen, he enrolled in a silversmithing class with a teacher he remembers as rather uninspiring. Ed's interest in making things may have been triggered at least in part by his older sister Helen who made jewelry. Even so, he was certainly far from committed to becoming an artist at this time. "I didn't think in terms of art at all when I was doing this metalwork. I was just going to school. One reason I enrolled in the class was that it gave me a small stipend to buy food. I was probably there for that as much as anything else. I never got very proficient at it."[18]

Through that class, though, he took a job as a low-level apprentice to Peter Mueller-Monk, then a silversmith and later one of America's best-known Art Deco designers. Ed did manual work, roughing out church chalices and other pieces Mueller-Monk designed. Ed's skills were marketable, and eventually he found a position working for the Austrian ceramist Valerie "Vally" Wieselthier. The Viennese-born Wieselthier had studied in Vienna at the Kunstgewerbeschule under designers Michael Powolny and Koloman Moser, proponents of the Vienna Secession style at the turn of the century. She then worked at the Wiener Werkstätte with designer Josef Hoffman, the most important Secession figure, before starting her own ceramic studio in Vienna. She emigrated to the United States at the end of 1928 to accompany her work that was to be included in the Metropolitan Museum's *International Exhibition of Ceramic Art*, an important show of modern European and American studio pottery. Wieselthier made simple, elegant functional ware in the tradition of modern Austrian ceramics, as well as larger-than-life-size ceramic figures.[19]

This was Ed Scheier's first involvement with ceramics, although it seems Wieselthier's personality had more of an impact on him than her work. "She was a remarkable woman, a strange and wonderful and eccentric figure." He recalls that Wieselthier was offered a job at a state university, and went there dressed in some kind of wild outfit with shorts. When her employers told Wieselthier her attire was inappropriate and that she would have to conform to the more staid atmosphere of the place, she became terribly outraged and upset. "She sent a telegram to the president of the United States saying: 'Tell these people who I am!'"[20] Ed did not have the opportunity to work with clay in Wieselthier's studio – she had other assistants more experienced than he, and his work involved making molds and doing other menial studio tasks. Nonetheless, Ed was sufficiently impressed with Wieselthier's work to make a mold from one of her plaster casts. Today the Scheiers still own a cast made from Ed's mold of this Wieselthier piece.

At this point, the late 1920s, Ed still had not marked out any clear direction for his life, although his work for Mueller-Monk and Wieselthier had aroused a serious interest in art. He had visited some of New York's art museums, but he was not particularly attuned to what was happening in the art world of New York or anywhere else. The stock market crash and the onset of the Depression had changed things, and he continued to work at all sorts of odd jobs, simply to get by.

One of his jobs was working as a baker at night for the *Herald Tribune*, at a time when the newspaper had its own restaurant. "They didn't keep anything over from one night to the other, so I would gather up all the unsold bread and cakes and give them to people I knew. One was the sculptor Jose de Creeft. He was as poor as all the rest of us. Max Bodenheim, the poet, was always hanging around the [Tribune] restaurant, too, waiting for someone to buy him a cup of coffee."[21]

"Part of my education was the Cooper Union Forum, held in the Cooper Union auditorium, where they had lectures two or three times a week, given by Mortimer Adler, Scott Buchanan, Lewis Mumford and many people who

became quite famous. These lectures were attended by the oddest collection of people — very often bums wanting to get in out of the cold. It was a wild and wonderful time. Everybody was poor and that was the great thing. There were all these things happening, and no one charged anything for them."[22]

The times were difficult, but Ed's social consciousness and his resolute spirit, not to mention his irrepressible and irreverent sense of humor, thrived. At one point, Ed worked as a bellboy in the University Club. "That was interesting because I was a young radical and Herbert Hoover used to come to the Club regularly. He would sit in the library reading, and part of my job was to bring him coffee and little servings of caviar. And I, to protest the capitalist system, would skim off some of the caviar on the way up from the kitchen in the elevator. I hated it at first, but I developed a liking for it. I was eventually caught and fired, and there I was out on the street without a job and with a taste for caviar."[23]

1. From an interview by Michael Komanecky with Mary and Edwin Scheier, January 17, 1992, in Green Valley, Arizona
2. Komanecky-Scheier interview, January 17, 1992
3. "Edwin and Mary Scheier," *Bulletin of the American Ceramic Society*, vol. 22, no. 8 (August 15, 1943): 264–265
4. Komanecky-Scheier interview, January 17, 1992
5. From an interview by Michael Komanecky with Mary and Edwin Scheier, April 12, 1993, in Green Valley, Arizona
6. Komanecky-Scheier interview, January 17, 1992
7. Beaumont Newhall, *The History of Photography from 1839 to the Present Day* (New York: The Museum of Modern Art, revised edition 1978): 107
8. Komanecky-Scheier interview, January 17, 1992
9. Komanecky-Scheier interview, January 17, 1992
10. Komanecky-Scheier interview, January 17, 1992
11. Komanecky-Scheier interview, January 17, 1992
12. Komanecky-Scheier interview, January 17, 1992
13. Komanecky-Scheier interview, January 17, 1992
14. Komanecky-Scheier interview, January 17, 1992
15. Komanecky-Scheier interview, January 17, 1992
16. Komanecky-Scheier interview, January 17, 1992
17. Komanecky-Scheier interview, April 12, 1993
18. Komanecky-Scheier interview, January 17, 1992
19. For information on Wieselthier's work, see Robert Yoskowitz, "Valerie Wieselthier in America," *Arts and Crafts Quarterly Magazine*, vol. IV, no. 4 (1991): 35–37; and Barbara Perry, editor, *American Ceramics. The Collection of Everson Museum of Art* (Syracuse: Everson Museum of Art and Rizzoli International Publications, Inc., 1989): 123–125 and 190–191
20. Komanecky-Scheier interview, January 17, 1992
21. Komanecky-Scheier interview, January 17, 1992
22. Komanecky-Scheier interview, January 17, 1992
23. Komanecky-Scheier interview, January 17, 1992

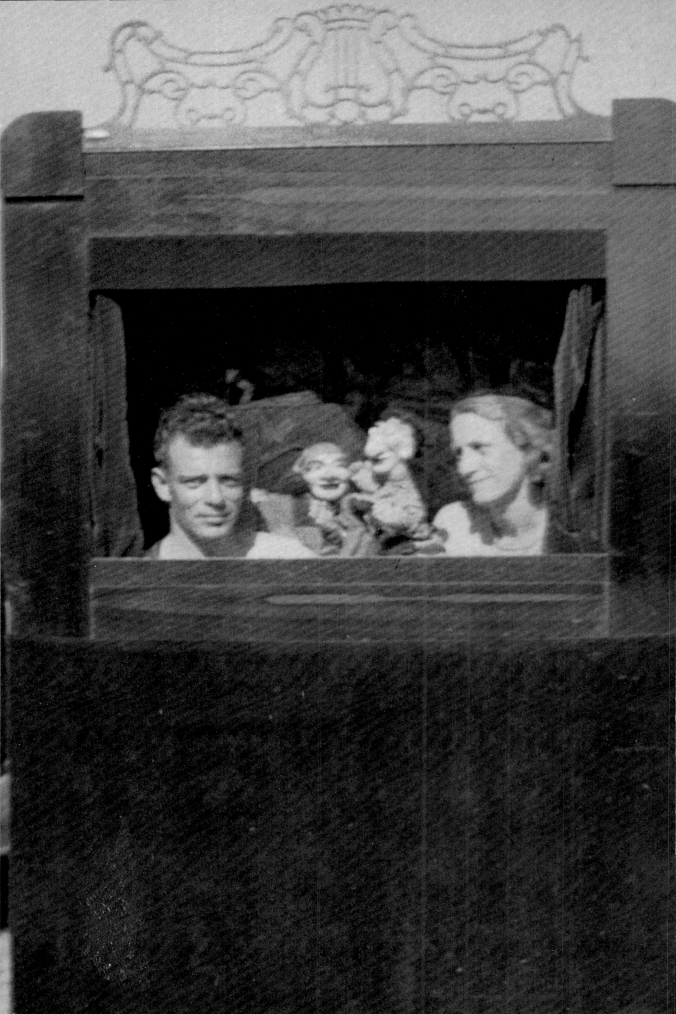

CHAPTER TWO: *Public Works, Public Art*

THE GREAT DEPRESSION was a formative experience for both Mary Goldsmith and Edwin Scheier, as it was for most Americans of their generation. For Ed, figuring out how to get by was just part of the adventure that the Depression presented. Possessed of unusual intellectual curiosity and innate intelligence, Ed seemed to take advantage of every opportunity that came his way.

His emerging radical politics found a new means of expression, something beyond the prankishness of his teens: he started presenting puppet shows. "I had to do my part to tear down the capitalist system. I don't know how or why I happened onto puppeteering, but I had this little show that I did at Union Square. It was mostly very crude propaganda, and I would get chased off by the police."[1] When Ed had the opportunity to attend a publicly supported program in puppeteering, he enthusiastically participated. "Then I went to a class, again a public works class, with Rimo Buffano, a well known Sicilian puppeteer. I worked with him for a couple of weeks."[2]

Through this experience with puppeteering, Ed was hired by the Federal Art Project (then known as the Federal Resettlement Project) in New York in 1937, sponsored in large part by the Works Progress Administration and its many programs. He was sent to Glens Falls, New York, where one of his responsibilities for the Federal Art Project was to develop a traveling puppet show that he would be responsible for taking around to various Civil Conservation Corps camps. "I built a stage, I had a little car, and I went around to ten or twelve CCC camps scattered around New York state. There were kids there, seventeen years old or so, but also men thirty or forty or fifty years old, unemployed, just desperate people getting

a dollar a day to work on parks, dams, and things like that."[3]

Later, Ed developed and taught craft courses at these camps. "There were men there who were skilled carpenters and they made all sorts of great things. I was the instructor but, of course, they were much beyond me. The camp became a place where politicians would go to see the results of the CCC program. So I got a lot of credit that I didn't deserve, up to the point where they asked me to come to Washington."[4]

Ed was appointed a coordinator for the Federal Recreation Project, traveling and developing programs for places in Louisiana, Mississippi, Alabama, and Tennessee. His travels took him on one occasion to Black Mountain College in North Carolina, where he met Josef and Anni Albers, although his itinerary was usually far less eventful. "I was given a panel truck, and there were supposed to be three of us, one each for crafts, drama, and music. One of the three was Vincent Price, the future Hollywood actor, who found a much better job. So there were two of us left, me and Walter Van Dyke. We would go to various places all through the South to give workshops to recreation workers on leatherwork, making belts and wallets, simple weaving, making puppets, puppeteering [Fig. 2]."[5]

Ed Scheier's success with these programs eventually led to his appointment as Field Supervisor for the Southern States of the Federal Art Project in Kentucky, Virginia, and North Carolina, where he continued to organize art and craft classes at newly established federal art centers. One of these trips took him to rural western Virginia, where among other things he was responsible for arranging shows of art work done by children in nearby schools. His duties brought him to the Big Stone Gap and Abingdon Art Centers, the first federal art galleries in Virginia. The director of these art cen-

FIG. 1. Mary and Edwin Scheier puppeteering in Florida, December 1937

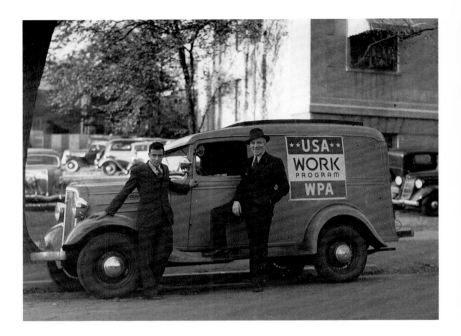

FIG. 2. Ed Scheier and Walter Van Dyke in front of their WPA van, 1937

ters was Mary Skinker Goldsmith.

Mary and Ed had not seen each other for almost five years since their chance meeting in the Metropolitan Museum. Mary had left New York in the spring of 1933, after friends in Virginia told her that there were opportunities to find work there in the new Federal Art Project and that one did not have to be on relief to qualify.[6] This possibility appealed to her as a way of using her art training, and in 1935, she was appointed director of the Big Stone Gap and Abingdon Art Centers. She lived with a well-to-do family in Big Stone Gap, a coal mining town, which kept her expenses to a minimum.[7]

Mary quickly made use of her talents as both teacher and administrator. Finding no art programs in local schools, she organized classes, teaching painting and modeling each week to as many as five hundred children after regular school hours. And in the segregated south of the 1930s, she boldly sought to involve African-American children and families in her programs. Wondering if there would be enough interest among these families to arrange a class for them, she met with African-American community leaders to explain what she had in mind. She received an enthusiastic response

and began teaching art classes for their children. Later on she and Ed taught various courses to all who were interested, black or white and sometimes in the same classroom – until word came back from federal officials in Richmond that their classes were to remain segregated.[8]

Her second chance meeting with Ed Scheier was more memorable than their first. Mary had been informed by her superiors that the unidentified Field Supervisor was coming for a visit, causing no small amount of trepidation on the part of Mary and her assistant. Having done all they could to straighten things up, they anxiously awaited the supervisor's arrival. Eventually, Mary noticed a panel truck pull up. Judging from the vehicle and the timid appearance of the man who got out of it, Mary thought they were being paid a visit by a candy salesman. The shy Ed Scheier – looking more scared than she was, she recalls – eventually poked his head in the Art Center door and introduced himself as the feared Field Supervisor.[9] At first, neither Mary nor Ed recognized each other from their meeting at the Metropolitan a few years earlier. Their professional interactions at Big Stone Gap, however, gave them the opportunity to get to know

each other. Mary and Ed began to spend time together socially, and their relationship flourished. On August 19, 1937, they were married by a justice of the peace just over the border from Abingdon in Tennessee.

Although they had enjoyed their work in the various WPA programs with which they had been associated, they decided to resign their positions. Mary and Ed both felt some insecurity with the Federal Art project; constantly supervised and always in danger of losing their jobs, they opted to take off on their own. Their chosen livelihood was one of Ed's old standbys, puppeteering, and together they created the "Pop Up Puppets." [[Fig. 1,3]][10]

With the help of Ed's sister in New York, they found and bought a used delivery van and trailer. They packed up their puppet show and toured through Florida and other southern states that winter, sometimes giving free performances for the various areas' needy children. Some of their shows were standard puppet fare, such as Punch and Judy skits, while others were intended as a means of presenting health and other civic programs.[11]

Their puppeteering experiences were rich. In Florida, the Scheiers found themselves tucked behind their puppet stage while a civic leader spoke to a crowd of hundreds of children who, like the Scheiers, were eagerly awaiting the start of the show. As the gentleman's oratory began to expand with no immediate end in sight, Ed, not realizing the puppet stage microphone was turned on, muttered to Mary something along the line of "Why doesn't that windbag bastard just shut up?" According to

Ed, it surely wasn't the first time these children of the working-class poor had heard rough language, and the auditorium broke into uproarious laughter. The show went on soon after that, as did the Scheiers – their engagement had been promptly terminated.[12]

The Scheiers' puppet shows were indeed engaging. In Florida, a little girl in the audience so fell in love with one of the puppet characters, a tramp with red hair, that she followed the Scheiers to the next town, and would consent to go home only when they gave her the puppet. On another occasion, the Scheiers' street-corner puppet performance had literally brought traffic to a standstill, and they were arrested on a charge of obstructing traffic. The judge, not exactly clear about how they managed to cause the traffic jam, wanted to fine them five dollars for each unlicensed "puppy" they had. When the Scheiers showed the judge puppets instead of a dog, he was so taken that he bought a whole set of them for his children, and dismissed the Scheiers' case forthwith.[13]

FIG. 3. Mary and Edwin Scheier puppeteering in Florida, December 1937

In April 1938, the Scheiers' talents with puppets brought them a new opportunity, again through the WPA: Ed was made director of the Anderson County Federal Art Center in Norris, Tennessee. There they converted an old firehouse into a workshop where they taught courses in metal, wood, leather, drawing, and painting, as well as classes on puppeteering. The Scheiers' puppet characters and skits were playfully inventive – Mrs. Dripping Gold, Professor Kookoo, Chief Worry Wort, Mae West, The Farmer's Wife, and the Rooster were among the dozens they created. Monkeys, devils, crying babies, and clowns also populated their puppet stage. The Scheiers' skits, along with their teaching abilities, inspired children to attend classes at the Center and to explore their own creativity.[14]

The benefits the young married couple enjoyed at Norris provided a frugal but comfortable – and entertaining – living. Often, the entertainment would be unexpected, if not exciting. "When we were at Norris, we had a number of people who worked with us in the WPA. We held classes in some of the rural communities as part of the TVA (Tennessee Valley Authority) outreach program. We would go into these isolated hollows and meet wonderful people. There were always roads in, for the bootleggers to get to the stills. There was a little danger until folks got to know who you were. They might take a shot at you, thinking you were a revenue person looking for stills."[15]

More importantly, however, in Norris another door opened that would change their lives. There they met Dr. Hewitt Wilson, the chairman of the Ceramics Engineering Department at the University of Washington. Wilson was brought to Norris by the Tennessee Valley Authority to serve as director of the TVA's Ceramics Laboratory. Wilson was in charge of developing the TVA's technology to produce high quality industrial ceramics, particularly with the use of newly invented electric kilns.[16] Wilson suggested that the Scheiers try doing some work in clay. They had already used clay to make their puppets, and while in Virginia, Mary had organized classes using local clays to make sculpture, puppet masks, and even simply bowls and jars. They both found the suggestion intriguing. Wilson invited them to visit the Ceramics Laboratory, located in Norris, where skilled potters were working on industrial applications for ceramics. Wilson offered the Scheiers a deal: if Ed and Mary would tend the industrial kilns at night, they could use the facilities as they wished.[17]

The Scheiers took advantage of basic instructions offered by Dr. Wilson, George Fichter, Patricia Eakin, and other members of the Laboratory staff, even reading Wilson's highly technical book on ceramics. More importantly, they simply experimented. "They had all the chemicals available. At night we would go down there after working at our jobs in the daytime, and go in and experiment. They had tunnel kilns, continuous kilns. You put things in one end and they came out fifteen hours later at the other end, so you could take chances with things."[18] Some of the Scheiers' earliest pieces there were cast porcelain figures.

Their experiments led them to expand Art Center programs by teaching pottery. Forced to be ingenious by lack of funds, Ed and Mary made a potter's wheel from the parts of an old Model T Ford. At the suggestion of Bruce Doyle, a member of the United States Indian Service who was visiting in Norris, they made their kiln from an old oil drum laid on its side, and fired it with coal and wood.[19] Using local clays, they began to teach modeling and pottery classes for housewives, school teachers, and mill workers from surrounding towns in Anderson County. Once again, the Scheiers' inventiveness served to inspire not only themselves, but those they gathered around them.

They became more and more interested in the possibilities of making pottery. Ed recalls: "When we were in Norris, we sought out some of the folk potters. They were very nice people, and we learned a lot from them. Not specific things, but an overall sense of what they were trying to do in the tradition that they worked in. They were making a living as potters, making jugs for dairies and local markets, dishes, and things like that. The potters

we liked, the ones we visited regularly, were just sweet, simple people. There was one potter who used to grind up Milk of Magnesia bottles to get his glaze – a nice glaze. There was a camaraderie among them in the Depression. All of them were struggling, yet they were generous people."[20] Characteristically, for the Scheiers, it was what these people were like rather than what they made that interested them most.

Yet, what these folk potters made was also important to the Scheiers. "We began to absorb something of the American tradition in pottery…and we had a desire to begin to create things that would be a natural outgrowth of this tradition."[21] They were sufficiently inspired, in fact, to make another dramatic move. They decided to leave their positions in Norris to strike out on their own again – to see if they could earn a living making pottery.

1. Komanecky-Scheier interview, January 17, 1992
2. Komanecky-Scheier interview, January 17, 1992
3. Komanecky-Scheier interview, January 17, 1992
4. Komanecky-Scheier interview, January 17, 1992
5. Komanecky-Scheier interview, January 17, 1992
6. Komanecky-Scheier interview, April 12, 1993
7. Komanecky-Scheier interview, January 17, 1992
8. Komanecky-Scheier interview, January 17, 1992
9. Komanecky-Scheier interview, April 12, 1993
10. Elise Torbet, "Mrs. Dripping Gold, Prof. Kookoo and Their Creators, Cause of Puppet Popularity among Residents at Norris," *The Knoxville News-Sentinel* (undated 1938 article)
11. "Needy Given Christmas Joy," *The Tampa Daily Times* (December 25, 1937)
12. Komanecky-Scheier interview, January 17, 1992
13. Torbet, "Mrs. Dripping Gold"
14. Torbet, "Mrs. Dripping Gold"
15. Komanecky-Scheier interview, January 17, 1992
16. Komanecky-Scheier interview, April 12, 1993
17. "Edwin and Mary Scheier," *Bulletin of The American Ceramic Society*, vol. 22, no. 8 (August 15, 1943): 264–265
18. Komanecky-Scheier interview, January 17, 1992
19. Elise Torbet, "Ancient Art of Pottery Making is Revived at Workshop at Norris with Potter's Wheel Made from Old T-Model," *The Knoxville News-Sentinel* (August 30, 1938)
20. Komanecky-Scheier interview, January 17, 1992
21. Jane Birchfield, "Clay Magic," *Richmond Times-Dispatch* (October 22, 1939): 7

CHAPTER THREE: *Hillcrock Pottery*

In the early fall of 1938, Mary and Ed Scheier packed their belongings into their puppet truck and trailer and set out from Norris toward Mary's childhood home in southwest Virginia. Enroute good fortune befell them once again. While driving on a muddy backroad near Glade Spring, their truck had a flat tire. While changing it, Ed's clothes became covered with wet mud. Later, when trying to remove the dried mud from his clothes, Ed examined the clay more carefully. In his previous experience as Field Supervisor for the Federal Art Project in Virginia, he had been required to determine whether local clays could be used for modeling and potting. After examining the clay on his clothes in Glade Spring, Ed thought it might be well suited for making pottery. The Scheiers then decided to stay and see if they could start their pottery business right there.[1]

They found a place to live on Route 11 – renting what could only be described as a ramshackle wood cabin. The cabin had history: it had been the first post office west of the Blue Ridge Mountains, and Andrew Jackson was reputed to have spent a night there. On the first floor was a room for throwing, and there was a sleeping loft upstairs. A building next door, formerly an old country store, served as a workshop. Having little money, the Scheiers made do, as they had many times before, with ingenuity and hard work. Beginning with their old Model-T wheel, they made another using an old sewing machine.[2] For a kiln, they used second-grade brick, a few pieces of steel, cement, and a coat of lime wash. By the summer of 1939, they could truly claim to be potters, having established Hillcrock Pottery.

They began by using three clays found within a radius of ten miles: the red clay previously discovered while changing their flat tire, a blue swamp clay found near Clinchburg, and a white

FIG. 1. Hillcrock Pottery, Glade Spring, Virginia, 1939

FIG. 2. Loading the kiln, 1939

clay. They blended the clays together, mixing them first in water and then sifting it through a fine screen before drying it sufficiently to be worked. As for glazes, they experimented with emulating ancient Persian red and gray glazes, as well as trying a red glaze akin to the ancient Chinese redware they had admired at The Metropolitan Museum of Art years before.[3] Experimentation was the operative word for almost all they did at Hillcrock. "It was all empirical. We learned from the North Carolina potters about Albany slip, and we would use that on the inside to make vessels waterproof, and just use the clay on the outside, without glazing. We didn't keep formulas or notebooks on glazes."[4]

From the beginning, there was a sense of excitement for the Scheiers as they waited for things to come out of the kiln. "When we started in Virginia, we had a great big traditional folk kiln called a groundhog kiln. That was a big kiln, and there were many things in it and sometimes they would all be ruined. We used local soft coal and smoked up the whole neighborhood!"[5] It was a big kiln, capable of holding as many as six hundred pieces at once, and even with the failures natural to a trial-and-error process, there were notable successes

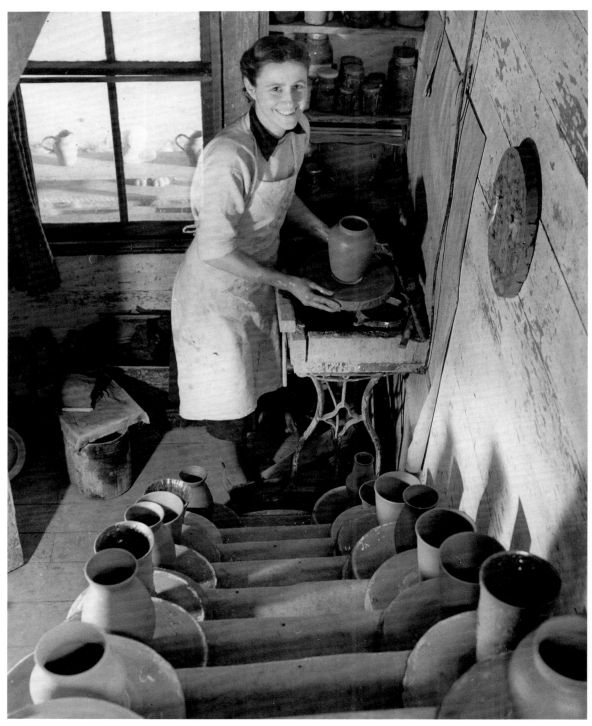

FIG. 3. Mary Scheier at the wheel at Hillcrock Pottery, 1939

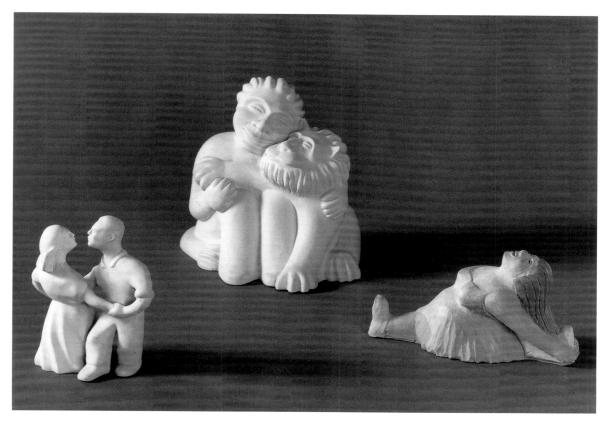

CAT. 2, 1, 4

[Fig. 2]. Their earliest wares included cookie jars, ashtrays, pots, vases, and bowls of a traditional nature, of which little seems to have survived [Frontispiece]. They worked hard, to be sure: Mary was capable of throwing as many as two hundred miniature pitchers at the wheel in one day.[6]

From the beginning, their work was collaborative. Mary did nearly all of the throwing. She had learned a little about throwing from some of the North Carolina potters she and Ed had visited, but just as influential was the illustrated book on pottery by the Alfred University ceramist Charles Fergus Binns[7] as well as *A Potter's Book* by Bernard Leach.[8] Mary mastered the task quickly, through practice and through intuition. "I felt the clay in my hands; it just seemed so natural to work it. I really loved it [Fig. 3]."[9] Ed wedged the clay, glazed the pieces, and fired the pots in their groundhog kiln. But even at this early stage, Ed also

threw a few pieces, learning a part of the craft that he would continue to develop for the rest of his life.

Both Ed and Mary made sculpture in clay. Mary made several small scale genre figures with descriptive titles: *The Washerwoman*, *The Gossip*, *The Hymn Singer*, *The Old Man with the Long White Beard*, and *The Square Dancers* [cat. 2].[10] Mary's venture into sculpture was not without precedent, as she and Ed had made puppets from clay for their work with the WPA. Another early sculptural effort at Hillcrock had been a large wooden pie cupboard bought in Virginia, on whose doors Mary had carved applied reliefs showing two potters at work, symbolic self-portraits of her and Ed.

Ed made clay figures similar to Mary's – a ballet dancer for instance [cat. 4] – modeled from clay and fired, and like Mary's figures occasionally glazed. Ed also produced some

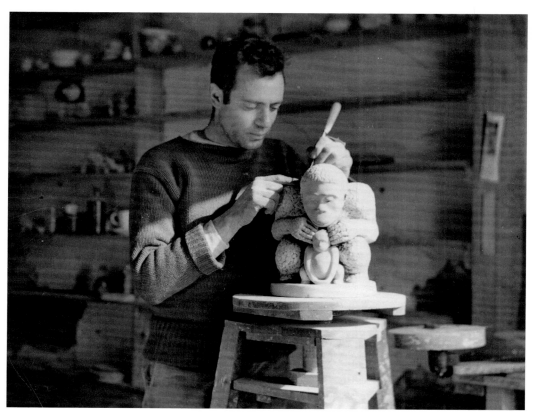

FIG. 4. Ed Scheier sculpting at Hillcrock Pottery, 1939

small-scale whimsical figures of pigs and horses, as well as some larger-scale clay pieces of horses [cat. 5], monkeys, and one of *Androcles and the Lion* [cat. 1]. Ed, too, had experimented with making sculpture earlier in his life, notably a small wood figure done around 1917, and his mold-making training with Mueller-Monk and Wieselthier had given him experience in working in three dimensions. He clearly enjoyed using clay as a medium for his sculpture [Fig. 4].

This early work seems to reflect a variety of influences or perhaps more precisely, the awareness of both Mary and Ed of concurrent developments in contemporary art. Mary's small-scale figures and wood carvings are generically related to the Social Realist work of the 1930s, whether done by major painters, printmakers, or sculptors of that movement, or as interpreted by the creators of architectural sculpture which was highly visible not only in New York but in WPA-era buildings through-

out the country. In contrast, Ed's sculpture suggests a more idiosyncratic personality; in comparison to Mary's relatively stoic figures, Ed's are more whimsical in both form and expression.

Their utilitarian pottery demonstrates firm roots in the American folk tradition. The Scheiers were keenly aware, even at the time, of the influence of mountain folk potters they visited in North Carolina, Kentucky, and Tennessee. While living in Norris they made trips to the Hilton, Bybee, and Jugtown potteries.[11] In addition, there was the Scheiers' developing knowledge of the art of other cultures. "We went to the [1939] World's Fair – that was a real influence! Israeli, Czech, Polish pottery. Our first exposure to [contemporary] pottery made outside this country. There was such excitement when we saw those pieces."[12]

Whatever the impact of outside influences, there was above all else the Scheiers' abilities

to infuse their work with their own individual characters. Some of this ability can be attributed to strong artistic wills, but some can also be attributed to a relative lack of knowledge of what America's more sophisticated potters were doing during the 1920s and 1930s. The Scheiers' geographic isolation, along with their relatively late-developing interest in pottery, well after their artistic training and apprenticeships, served to segregate them. "We were completely absorbed with what we were doing, and didn't know much about what other people were doing. The only things we had really seen were Chinese pots." For the Scheiers, this was no disadvantage. "We were fortunate in that we hadn't had any schooling in clay or pottery. We didn't know how to do things. If we had, we probably would have been in the same position as so many students that just think like one another or like the instructor. We created some remarkable glazes without knowing they were remarkable."[13]

The Scheiers' work began to attract attention, first among their farm neighbors in Glade Spring. As Hillcrock Pottery got under way, the Scheiers often bartered for food and furniture, trading pottery and even the chance for their "customers" to fashion things of clay themselves. A reporter interviewing the Scheiers noted that "before long, every young person in the community was coming to Hillcrock for part of the day. When they weren't learning how to prepare the clay and to model, they were carrying wood for the kiln, digging clay – doing anything so the Scheiers would let them stay around."[14]

Many of the figure pieces were so popular among the local residents that Mary made molds of them so that she could sell more of them, at the low cost of fifty cents each – when they sold. The Depression was still strongly felt in these rural areas, and everyone, including the Scheiers, was happy just to get by. Some of Mary's figures were sold through a New York shop, where they were acquired by Robert Porterfield of the Barter Theater. He was looking for a trophy to give the actress Lorette Taylor for her performance as Mrs. Midget in

Outward Bound. Porterfield chose *The Washerwoman*, and he also bought *The Square Dancers* for Eleanor Roosevelt, who presented the award to Taylor.[15]

This was just the beginning of the Scheiers' recognition. Their roadside stand was also noticed by Kenneth E. Smith, a well-known potter and teacher at Newcomb Pottery in New Orleans who was traveling through the area.[16] He liked the work he saw at Hillcrock, and suggested that the Scheiers try to attend a conference of the American Ceramic Society to be held in relatively nearby Black Mountain, North Carolina. The Scheiers decided to go, financing their trip by selling their wares along the way, including "a bushel of miniature pitchers and a large drove of clay pigs to Clementine Douglas, Director of the 'Spinning Wheel,' a handicraft shop near Asheville, North Carolina."[17]

These miniature pitchers, some no more than an inch high, had become something of a specialty for the Scheiers. In their fledgling days at Hillcrock, the Scheiers were contacted by Southern Highlands in North Carolina to see if they would be interested in making vases for miniature roses. The Scheiers agreed and sold the vases for five cents apiece, attracting the attention of the Perkins Miniature Rose Company as well, which commissioned them to do more. The Scheiers accepted again, making some two thousand miniature vases, turned on the wheel, glazed, decorated, and fired.[18]

While attending the Black Mountain conference, the Scheiers also met Ross Purdy, a ceramics professor at Ohio State University and president of the American Ceramic Society. Purdy made a suggestion to the Scheiers that would prove even more important than Smith's. "He saw some of the crude things we were doing, and they were crude, and suggested that we send them to Syracuse to the Ceramic National competition."[19] Their entries were evidently not judged to be as crude as the Scheiers thought, for not only were three pieces accepted into this prestigious show, but one was awarded the Hanovia Chemical Company purchase prize at the Ninth Ceramic

National of the Syracuse Museum of Fine Arts [cat. 7, 8, 11].[20] From 1940 to 1958, in fact, with the exception of one year that they served as jurors, the Scheiers were awarded prizes at each of the annual ceramic competitions in Syracuse.[21] Despite the Scheiers' modest appraisals of the work they did at Hillcrock, it is clear that they had made vast strides in a short time. With the inclusion of their work in the Ceramic National exhibition, the Scheiers had begun to gain some prominence and had entered the larger world of American pottery.

1. Marian Eller, "Flat Tire Led to Founding of Smyth County Pottery Plant," *The Roanoke Times* (November 26, 1939): 1
2. Birchfield, "Clay Magic," 7
3. Eller, "Flat Tire"
4. Komanecky-Scheier interview, January 17, 1992
5. Komanecky-Scheier interview, January 17, 1992
6. *Bulletin of The American Ceramic Society*, 270
7. Interview by Michael Komanecky with Mary and Edwin Scheier, Manchester, New Hampshire, April 29, 1992
8. Bernard Leach, *A Potter's Book* (London: Faber and Faber Limited, 1940)
9. Komanecky-Scheier interview, January 17, 1992
10. Birchfield, "Clay Magic," and Eller, "Flat Tire"
11. Komanecky-Scheier interview, January 17, 1992
12. Komanecky-Scheier interview, January 17, 1992
13. Komanecky-Scheier interview, January 17, 1992
14. Eller, "Flat Tire"
15. Eller, "Flat Tire"
16. Kenneth E. Smith, "The Origin, Development and Present Status of Newcomb Pottery," *Bulletin of The American Ceramic Society* 17 (1938)
17. *Bulletin of The American Ceramic Society*, 269–270; and Komanecky-Scheier interview, January 17, 1992
18. Komanecky-Scheier interview, January 17, 1992
19. Komanecky-Scheier interview, January 17, 1992
20. Perry, *American Ceramics*, 178, catalogue numbers 236–238
21. See *List of Exhibitions*

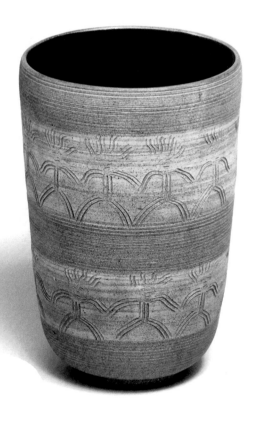

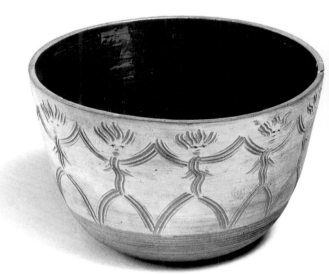

CAT. 8, 7

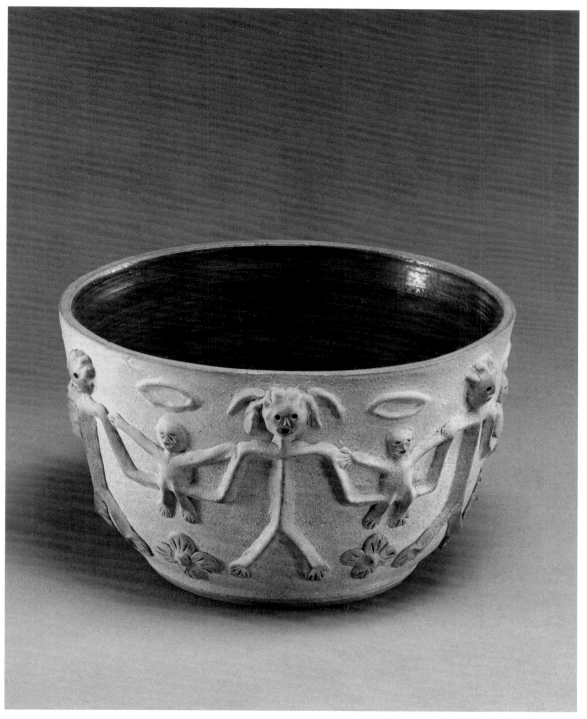

CAT. II

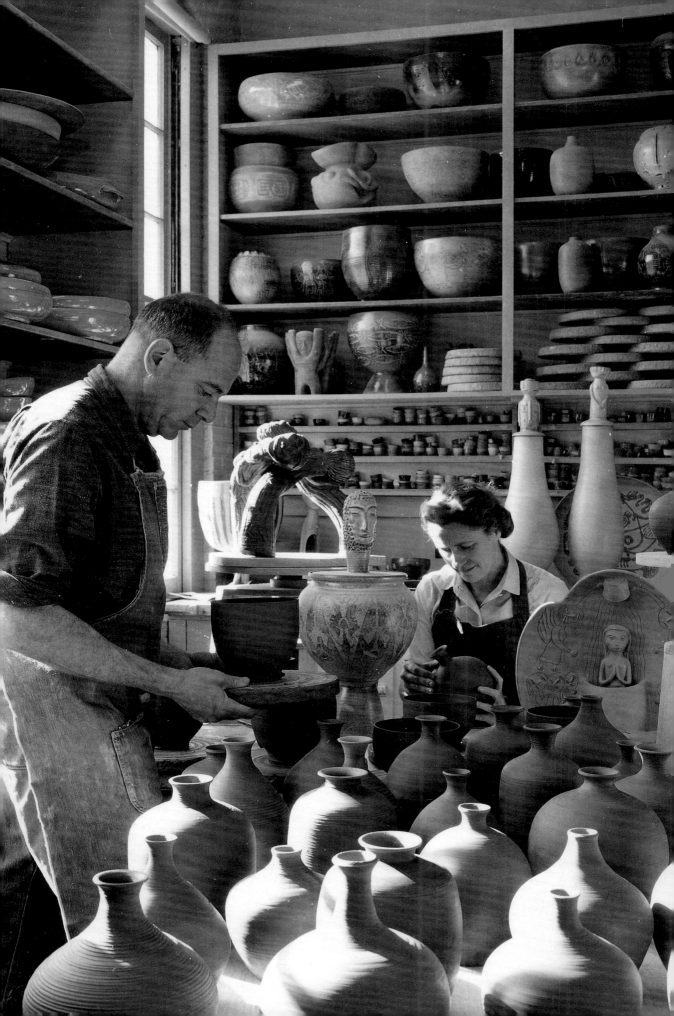

CHAPTER FOUR: *The Durham Years*

Within the span of little more than a year, the Scheiers had transformed themselves from puppeteers to potters, winning an award at a nationally renowned ceramics show. This success brought growing contacts among the pottery and crafts communities that proved immediately beneficial. David R. Campbell, director of the New Hampshire League of Arts and Crafts, was also at the Black Mountain ceramics conference and was impressed with the Scheiers' work. Campbell, deeply devoted to the success of the League, was eager to bring talented craftspeople to New Hampshire as part of the League. Campbell had helped set up summer craft fairs in the state where artists could sell their works, and he helped found a series of shops in New Hampshire that offered still another outlet for craft sales. His New Hampshire connections were formidable, so much so that he was able to help secure positions for Ed and Mary at the University of New Hampshire in Durham.[1]

Beginning with the fall semester in 1940, Ed was appointed an instructor in ceramics, and Mary, artist-in-residence in the Home Economics Department, which would eventually become the Department of Fine Arts. For the Scheiers, it was an unimagined opportunity. To have been made a university teacher was astounding to Ed, for regardless of his talents and life experiences, his formal education ended after the eighth grade. Mary's unpaid appointment as artist-in-residence gave her the freedom to use the university's pottery-making facilities, without the responsibilities of teaching, although she frequently assisted Ed in teaching classes during their twenty years at the University. As small as their income from teaching was, barely $1,300 a year, it gave them enough to

live on. Property in still rural New Hampshire was inexpensive; in fact, over the years, with the additional money they made from selling pottery, the Scheiers lived in a number of farmhouses that they bought and sold for little more than their annual salary.

The potting facilities were rudimentary. The Scheiers' first studio was in the basement of one of the classroom buildings. The Scheiers involved the students in every aspect of making pottery, recreating in some ways their own experiences at Glade Spring. In the early years at Durham, the Scheiers' students dug their own earthenware clay from an area near the football field. Later on, especially as their own pottery production increased, the Scheiers bought Canadian clay for making stoneware.[2] One improvement, however, was that the Scheiers and their students had an electric kiln that, although not so spacious as their Glade Spring groundhog kiln, required far less work to use.[3]

The Scheiers' schedule was a rigorous one. From the time of their arrival in Durham in 1940 until their retirement from the University and their eventual departure for Mexico in 1968, the Scheiers' working lives were defined by the daily ritual of making pottery: up early in the morning, throwing, decorating, glazing, and firing, working late into the night, day after day, week after week, month after month. In addition, they taught classes three or four days a week, including summer school. And, during their first year in New Hampshire they also taught a pottery course at the Concord headquarters of the League of New Hampshire Arts and Crafts, again arranged by David Campbell.

There were few interruptions in this demanding, self-imposed schedule. The onset of World War II, however, was one of them. In 1942, Ed volunteered for service in the Army Air Corps. After basic training in Dedham, Massachusetts, he was stationed at Lowry Field in Denver. Ed's mechanical aptitude, gained dur-

FIG. 1. Mary and Ed Scheier in the ceramic studio at Hewitt Hall at the University of New Hampshire, Durham, December 1956

ing his apprenticeships in New York as well as from his work with the Federal Art Project, led to training as a bombsight specialist.

While Ed was stationed in Colorado, Mary assumed his teaching responsibilities at the university. The war also provided an opportunity for her to make use of her experience as a puppeteer. The expectation that increasing numbers of wounded veterans would return to the States for treatment as the war progressed led to the development of occupational therapy programs throughout the country. In 1943, as part of a program for students interested in becoming occupational therapists, Mary began to teach classes on making and using puppets. These classes, in fact, gained press attention all across the country.[4]

The Scheiers' growing national reputations, due to their prize-winning results at the Ceramic National shows and the publicity that accompanied them, led to further opportunities for both Mary and Ed. In 1944, Mary was invited to teach ceramics for a year at the Rhode Island School of Design in Providence, and she continued to teach there following Ed's discharge from the Army Air Corps later that year. In the summer of 1945, they both went to Puerto Rico to work with the Puerto Rico Industrial Development Company, training native islanders to develop a pottery industry and to create employment.[5]

As part of his participation in the Operation Bootstrap project with the Puerto Rico Industrial Development Company in 1945, Ed spent a month traveling throughout the United States with a Puerto Rican administrator on the project. Their intent was to familiarize themselves with American crafts, a goal strongly supported by René d'Harnoncourt, director of the Museum of Modern Art in New York and the consultant to the Department of the Interior under whose aegis the program was carried out. Ed and his companion visited many artists, including the weaver Dorothy Liebes, and the potters Maija Grotell, Margaret and Franz Wildenhain, Otto and Gertrud Natzler, and Laura Andreson. By the 1950s, the Scheiers got to know most of the major American ceramists,

including Beatrice Wood and Antonio Prieto; the Scheiers traded works with Prieto, in fact.[6] Although the Scheiers had been isolated from the larger world of American pottery when they started Hillcrock, they were becoming intimately familiar with the works of most of the country's important potters.

After returning to New Hampshire in the fall of 1945, the Scheiers once again focused on making their own pottery. Over the course of the next two decades, centered in Durham, the Scheiers established themselves as two of America's most creative and productive studio potters. In addition to their repeated success in the Ceramic National shows, the Scheiers had numerous works photographed for inclusion in some of the country's most prestigious magazines: *House and Garden, Design, The New York Times Magazine,* and *The Christian Science Monitor* in the 1940s; and *American Artist, Ceramics Monthly, Glamour,* and *The New York Times Magazine* again in the 1950s.[7] The growing, relatively widespread emphasis on contemporary design in many American art museums after the war resulted in works by the Scheiers being acquired for museum collections[8] and being included in numerous special exhibitions.[9]

The Scheiers' contributions can be seen most clearly through a chronological and typological examination of the work that they produced in these years. They made numerous undecorated and decorated utilitarian wares. They also made decorated bowls, vases, and jars in which the decoration is so three-dimensionally vigorous that the works tend to lose their functional associations. In addition, there were occasions during this portion of their careers that clay served as a medium for pure sculpture. Another critical aspect of the Scheiers' work to be looked at is the narrative content in Ed's decorative designs. Ed's pervasive interest in biblical subjects is unique in American pottery, if not American art of the twentieth century. Finally, the highly collaborative nature of the Scheiers' working relationship must be considered; it is important to distinguish between works that the Scheiers did jointly and those that were made either by Mary or Ed separately.

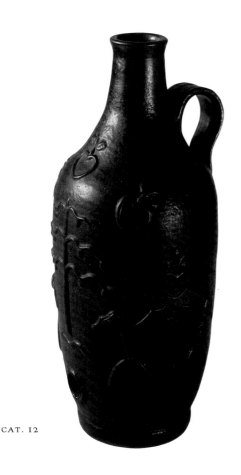

CAT. 12

CLAY SCULPTURE

One of the Scheiers' award-winning pieces at the 1940 Ceramic National exhibition was a bowl thrown by Mary and decorated and glazed by Ed [cat. 11]. The influence of North Carolina folk pottery can be seen in the bowl's dark brown Albany slip interior. Nonetheless, there is an inventive use of applied low relief decoration in this bowl, where alternating male and female figures are shown holding between them a haloed child. Although this kind of decoration, seen also in a black-glazed cider jug from the same date [cat. 12], relates to the pottery of Dorothea Warren O'Hara,[10] it is more reminiscent of the American folk tradition than of O'Hara's refined sculptural inclinations, much less those of Henry Varnum Poor, Waylande Gregory, or Viktor Schreckengost, all of whose pottery the Scheiers in any event did not know in the late 1930s and early 1940s.

After the war, Ed continued to make clay sculpture. In these works, entirely from his own hand, he combined his penchant for three-

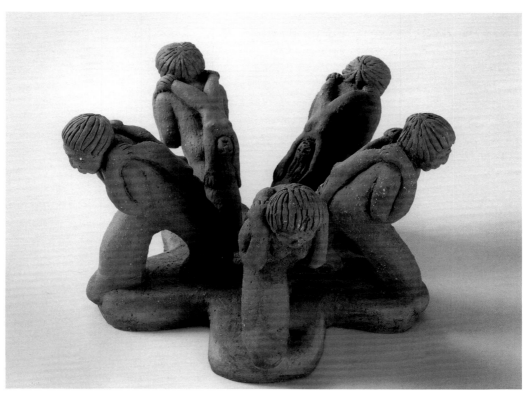

CAT. 6

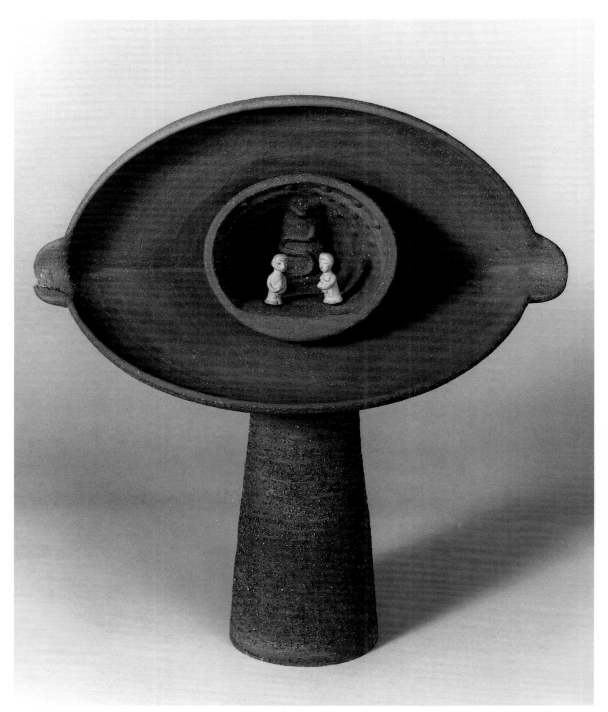

CAT. 77

dimensional expression and provocative subject matter, occasionally and brilliantly extending the boundaries of pottery in the process. One of the first post-war pieces [cat. 6] shows five figures arranged in a circle, carrying lifeless children on their backs while they stoically walk away from each other in a moving representation of the threat of nuclear holocaust. Its emotional content is consequently very different from the cheery and reassuring familiar environment seen in his and Mary's earlier prize-winning bowl submitted to the 1940 Ceramic National. In another work [cat. 69], four free-standing female figures are shown with their children still in their wombs. The mothers assuredly provide safety to their unborn children, yet the slight variations in facial expression, and the placement of each woman's hands and arms together as if protecting themselves from an invisible threat, create an unsettling psychic atmosphere.

This coexistence of isolation and familial protection, rife with both social and moral over-tones, is nowhere better seen than in a group of table sculptures done exclusively by Ed Scheier between 1945 and 1948. Each is a kind of miniature stage set, surely rooted in Ed's previous experiences with the ambiance and dramatic possibilities inherent in puppet theater. The comic skits of his puppeteering days have been replaced, however, by moving biblically-inspired dramas of temptation and redemption.

In four of them, Adam and Eve confront the consequence of succumbing to the devil's temptations. In one sculpture [cat. 77], Adam and Eve ponder their moral choice, standing in a cave-like enclosure containing the tree of knowledge and the serpent, a world enclosed within the larger world – mouth, head, womb? – that exists outside them. In another table piece [cat. 75], Adam and Eve hold their hands to their heads, and turn their backs on the open-mouthed serpent who deceived them. Adam and Eve's simple expressions, and the refined, smooth-surfaced semicircular stage create an environment in which beauty remains.

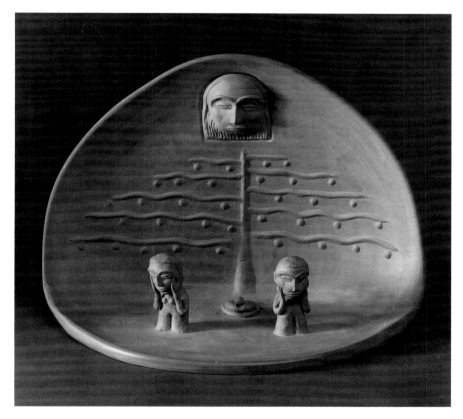

CAT. 75

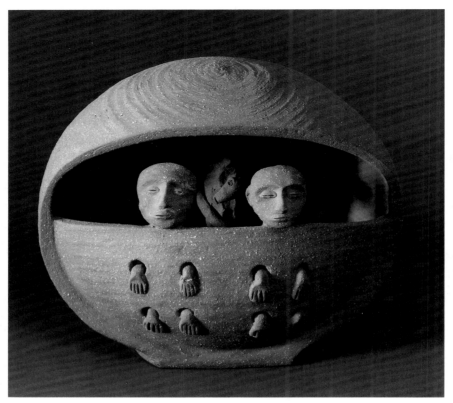

Despite Adam and Eve's fall, God is still benevolent, and at the very least does not curse his first children. The third sculpture [cat. 78], is by far the most punitive and pessimistic representation of the theme. It shows Adam and Eve trapped in a stock-like device, almost entirely enclosed in the serpent's lair. In contrast, in the last piece [cat. 76], Adam and Eve rest supportively on each other's shoulders within a shell-like cusp. Beneath them, their progeny, even while enwrapped in the serpent's grasp, reveals within its outwardly facing palms the symbolic children of future generations, as if to suggest that despite the fall, parental love will survive to nourish life.

The last two sculptures in this related group simultaneously juxtapose themes of birth and death, last judgment and redemption. The first [cat. 73] shows a tiny white-glazed figure lying in a small, open enclosure, just below the surface of a broad horizontal plain. Both the figure and its flat clay world are embraced by the arms and hands of a figure – God – whose face

emerges from the upturned semicircular back wall of this terra-cotta piece. God's kind expression and gentle embrace impart a sense of safe, peaceful repose for the resting-sleeping-dying-dead figure. In apparent contrast, in a near identical compositional structure [cat. 74, color plate, p. 19], the same God reaches out to enclose in his/her grasp a group of small black-, white-, and red-glazed figures who represent the world's many races. The devil has trapped some of each inside his low-walled circle, but the ambivalent facial expressions on these little figures suggest that judgment time has not yet arrived; redemption and safety may still be within their grasp.

These miniaturized morality plays are without parallel in American pottery or even American sculpture of their time. There is evidence that Ed was rapidly expanding the compositional and expressive figural sources upon which he drew for these early works. Whereas the influence of American folk pottery was important in his earliest animal sculpture, pre-Columbian art of Mexico and Guatemala increasingly

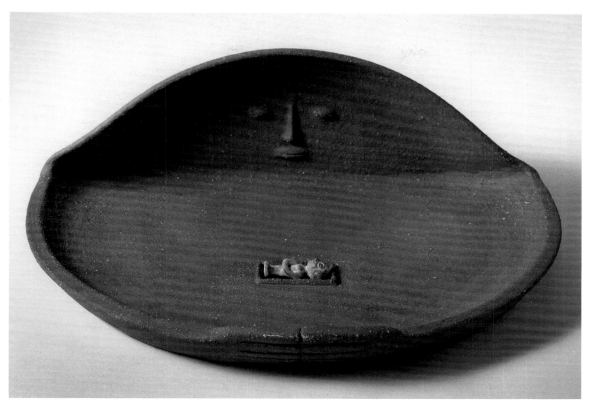

attracted his serious attention. The grouping of small glazed figures on a flat, stage-like plane, as in Ed's *Last Judgment* [cat. 74], for instance, recalls the appearance of Nayarit mortuary sculptures of ceremonial ball games.[11] The placement of larger single or paired figures against the shelter of a background wall [cat. 75, 76] is conceptually reminiscent of the way in which a deity emerges from a water lily, a common motif in Mayan Late Classic sculpture.[12] By the time Ed made his table sculptures in the late 1940s, Mary and Ed had visited museums in New England and New York, where he would have had ample opportunity to see pre-Columbian sculpture. The Scheiers also acquired mostly small- but a few large-scale pre-Columbian figure sculptures during their visits and their ten-year residence in Mexico, most of which they either gave away or left in Mexico before returning to the United States in 1978. By integrating formal and compositional aspects of pre-Columbian sculpture and pottery within the guise of biblical imagery, Ed Scheier created

contextual and emotional results, however, that were distinctly his own [see also cat. 79].

UTILITARIAN PIECES

By far the greatest proportion of the work the Scheiers made between 1940 and 1968 was purely functional in intent and design. Making bowls, vases, pitchers, mugs, cups, saucers, casseroles, sugars and creamers, tea and coffee pots, carafes, and dinnerware was an economic necessity, and the Scheiers undertook this work with an energy and talent that resulted in some of the best utilitarian ware by any studio potters during the period. Although the Scheiers made such pieces at Hillcrock, it was at Durham that they refined their skills as well as their production methods.[13] Mary threw nearly all of this pottery and occasionally glazed and decorated it herself, although usually Ed did the glazing. The earliest works were of earthenware, but from the early 1950s onward, the Scheiers used stoneware almost exclusively.

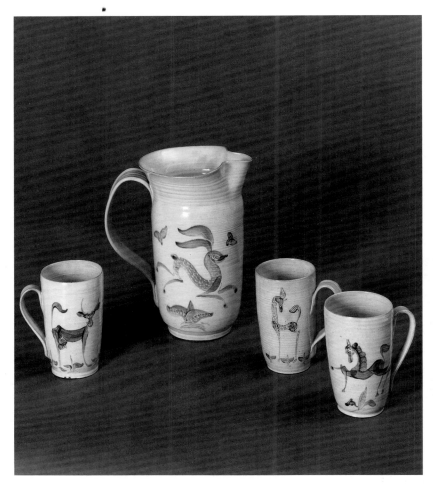

Gray-glazed mugs and pitchers [cat. 15] were an early staple and were extremely popular.[14] Their blue or grayish-black animal and floral designs, entirely from Mary's hand, are strongly reminiscent of those found on nineteenth-century American jugs and crocks. Mary also made undecorated carafes and matching handleless mugs. The carafes and mugs were usually glazed in pale gray, blue, or green, although occasionally richer, multicolored glazes were employed on the mugs. The carafe stoppers usually culminated in a small sculpted animal figure, thus combining in one piece Mary's interest in both pure form and sculptural embellishment [cat. 17].

Casseroles, too, were among those pieces produced in large numbers. They were made in varying sizes, from four inches to sixteen inches across. Glazes were restricted to shades of gray, brown, or turquoise, and sometimes a casserole

would be glazed in one color on the outside and another on the inside. Yet within the demanding parameters of making what Mary refers to as so many "potboilers," there is an undeniable integrity and appealing individuality in these handmade pieces. In the interior of a humble casserole [cat. 22, color plate p. 15] a sunburst pattern unexpectedly erupts, while a tasteful geometric sgraffito pattern drawn by Ed subtly enlivens the exterior of another [cat. 23, color plate p. 15].

Mary Scheier's tea and coffee services, in particular, reveal her superb sense of form and her highly disciplined abilities at the wheel. Glazed by Ed, they were produced from the early 1940s through the late 1950s. Their colors range from the simplest of monochromatic glazes, most often gray [cat. 16] but also pale blue or green, to rich and mottled glazes of browns,

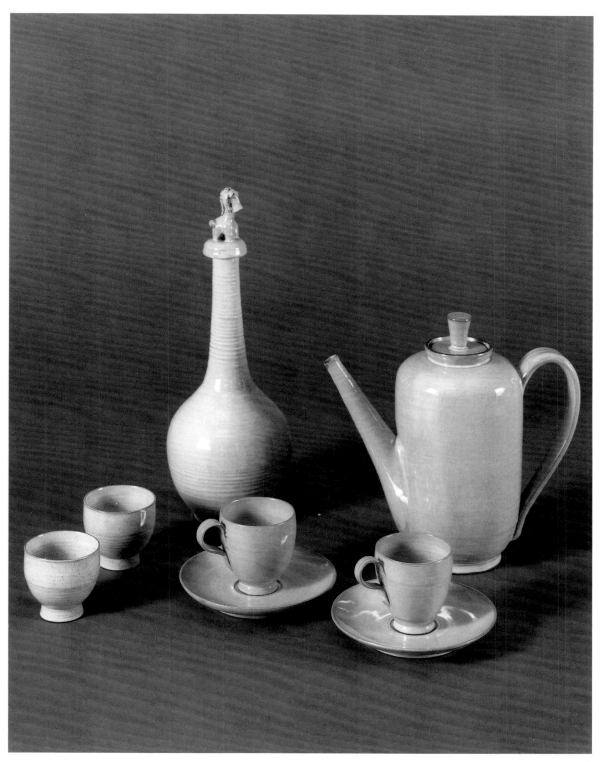

CAT. 17, 16

golds, and related earth tones [cat. 18, 24]. The elegance of these bulbous teapots, punctuated with simple, straight spouts and knobbed lids, as well as of the taller, slim vase forms of the coffee pots, is equaled only by the contemporary work of Laura Andreson and, to a lesser extent, Robert Meinhart.

Mary Scheier produced few sets of dinnerware – aside from sets she made for her and Ed, the only other sets were special commissions for friends. However popular and lucrative this type of utilitarian pottery might have been for the Scheiers, the tedium of making so many plates, bowls, cups, and saucers with little variation was rarely overcome. Nonetheless, of all the dinnerware sets made by studio or production potters from the late 1940s through the mid-1950s, there are none more handsome than those made by Mary Scheier. Again, these works were thrown by Mary and glazed by Ed. There are distinct variations in the half-dozen or so sets that they made: one set, for example, has high-gloss earth-toned glazes [cat. 25], while another has lushly varied gold and brown matte glazes and is augmented by casserole dishes, a teapot, and a number of serving bowls [cat. 24].

Undecorated bowls and vases also formed a large part of the Scheiers' earliest production and continued as a mainstay of their work through the 1960s. Mary made specialty pieces as well, such as a unique punch bowl and mug set [cat. 20]. As usual, Mary threw the bowls, vases, and cups, and Ed glazed them. Their talents combined to produce extraordinary results. There is a narrow but expressive range of bowl shapes and sizes: low, flaring bowls, straight-sided bowls, tiny finger bowls, thrown with the thinnest of stoneware walls and ranging in diameter from less than three inches to just over twelve. Moreover, the bowls are adorned with some of the most seductive glazes achieved by the Scheiers at any time in their careers [cat. 26–32, 34, 36]. One of the most unusual was a matte yellow glaze [cat. 46, color plate, p. 16] that they used either unadulterated or in combination with other glazes from the late 1940s until around 1958, when they discovered that

its chromium trioxide content was highly toxic and ceased using it. Some of the small vases and bowls from this period clearly indicate the Scheiers' admiration for the traditional forms of Chinese and Japanese pottery that attracted their attention from the very beginning of their careers [cat. 37, 38, 39, 41].

Only Austrian-born Gertrud and Otto Natzler's bowls are comparable in quality to the undecorated bowls by the Scheiers in this period. Like the Scheiers, the Natzlers were self-trained,[15] and they also separated their tasks in making pottery, Gertrud throwing and Otto glazing. Both Gertrud Natzler and Mary Scheier possessed great skills at the wheel and were able to throw delicately-shaped, thin-walled vessels whose classical forms frequently paid homage to ancient Chinese pottery. Similarly, both Otto Natzler and Ed Scheier discovered remarkable glazes. Unlike the Scheiers, who were involved in a studio production process for the majority of their functional wares, the Natzlers seem to have been more intent on making highly esoteric pieces. These differences in process and intent account at least in part for the more self-consciously exotic combinations of glazes and forms achieved by the Natzlers. In fact, it is hard to imagine actually using many of the Natzlers' extraordinary bowls, while the Scheiers' utilitarian wares continue to be used by the vast majority of private individuals who own them.

PLATTERS

Ed began making a new type of work entirely on his own shortly after the Scheiers returned from Puerto Rico in 1945. Although he continued to glaze and decorate pots thrown by Mary, he started to throw and decorate a number of round earthenware platters in a way that would occupy his creative energies for nearly a decade.[16] Measuring approximately ten to twenty inches in diameter, they were gently dished with slightly turned up edges, occasionally in the shape of broad, low bowls. These platters from the late 1940s and 1950s were functional, to be sure, but their fascination results

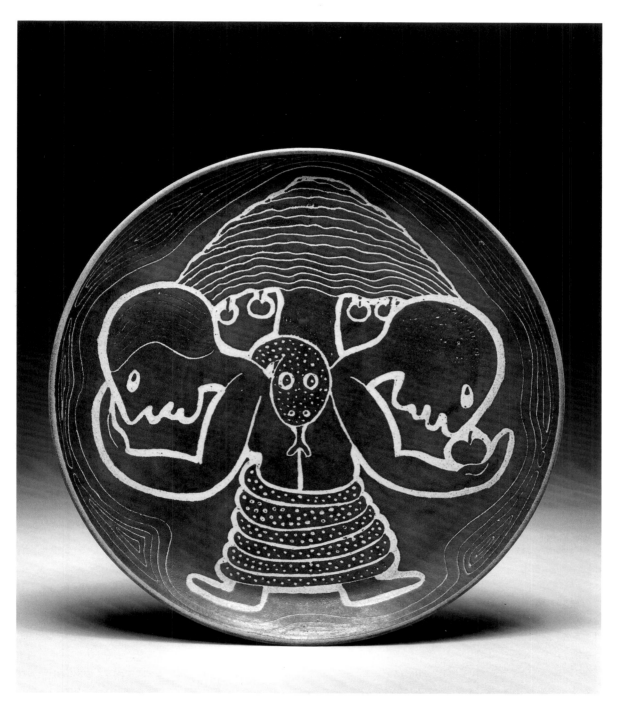

CAT. 51

from Ed's utilization of the surfaces as open fields for his rich and varied decorative schemes.

Some of the schemes strongly suggest the influence of contemporary painting. On one platter [cat. 46, color plate, p. 16], thick black lines, dripped and brushed onto the strongly contrasting matte yellow surface, are similar to the method if not the motifs found in Jackson Pollock's action paintings of the late 1940s. Ed experienced both the direct and indirect influence of the Abstract Expressionist art during the 1940s. In the summer of 1944, under the GI Bill, Ed took a drawing course with Hans Hoffman in Provincetown, Massachusetts. According to Mary, Hoffman took a great liking to Ed's work, and over the years, the Hoffmans and Scheiers became friends. As a sign of their friendship and mutual admiration of each other's work, the Scheiers traded two of their pots for two of Hoffman's paintings.[17]

Some of the platters are decorated with dark curvilinear abstractions of disjointed heads [cat. 59, color plate, p. 18]; others with strangely isolated yet interconnected figures [cat. 61, color plate, p. 18] or linear patterns of figure-like forms [cat. 60, color plate, p. 18] against a light, near-monochromatic background. These last platters, in which creatures float magically in a surreal world of the imagination, recall the works of the Surrealists and especially Joan Miró. Ed was not alone in making platters with designs borrowed from the language of contemporary painting. In the 1940s, Don Schreckengost, Whitney Atchley, and Sascha Brastoff made decorated platters, although each of them seems to have been interested in rather literal figure designs inspired by realist traditions.[18] Ed Scheier, in contrast, seems to have been the only potter during the 1940s to incorporate successfully such an abstract formal language into his work. Indeed, in his later writings, he readily acknowledges at least the indirect influence of contemporary art on his work.[19]

Although more or less realistically depicted human figures, too, form a common motif in Ed Scheier's platters, they become so densely intertwined as to suggest deeper meaning. The figures are either encircled, entrapped, or other-wise contained by the circle of the platter, and sometimes even by their own limbs [cat. 53, color plate, p. 17]. In some instances, the figures are arranged like spokes around a wheel, forming a family of men and women who protectively nurture their children at the hub [cat. 57, 58, color plate, p. 17].

By far the most consciously narrative of these platters are those whose subject is the temptation of Adam and Eve, a subject which Ed has mined continuously throughout his career. In one of the earliest, dating from 1945 [cat. 50, color plate, p. 17], Adam reaches out to grab the serpent by its throat, in what appears to be a fit of anger at having been deceived. The strong contrast of the dark brown, glossy-glazed figures against the gray underglaze emphasizes the psychological darkness of the moment. In another early platter, dating from 1951–52 [cat. 51], Adam holds the apple, while he and Eve stare down, dejected at their plight caused by their submission to temptation. Their plight is worsened by the large serpent who wraps his long, powerful tail around them, tying them to the tree of forbidden knowledge. Here, too, the strong contrast of black figures, defined by varying widths of sgraffito markings against a lighter gray underglaze, enhances the scene's ominous emotional tone. Ed would return again and again to the subject of Adam and Eve not only in his ceramics, but in his later ventures into weaving, painting, and sculpture.

DECORATED POTTERY:
BOWLS, JARS, AND VASES

Ed Scheier's use of platters as a field for figural decoration was extended to many other ceramic forms, all basically utilitarian but essentially transformed by the nature of his figural and narrative motifs. From the beginning, the creative enterprise was largely undertaken on a joint basis; Mary threw many medium-sized bowls and vases, for example, that Ed decorated, but the largest vessels were thrown and decorated by Ed himself. Although Ed occasionally made a preliminary drawing for a platter, the vessel decorations were drawn directly

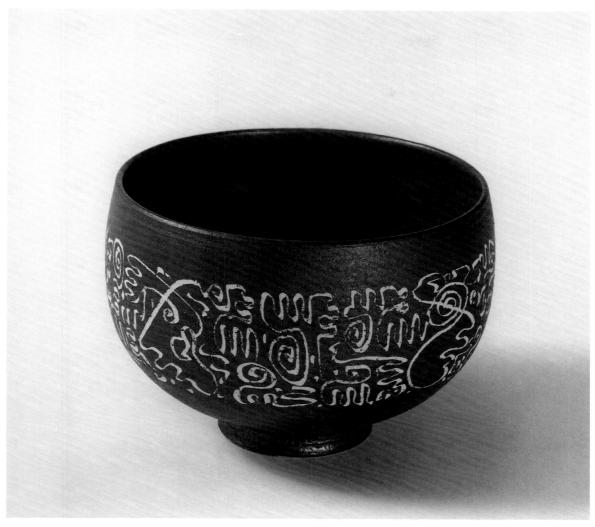

CAT. 66

on the clay without any preliminary studies.

During the late 1940s and throughout the 1950s, Ed's decorative motifs consisted of heads or figures technically as well as stylistically related to those found on his platters. In one of these early bowls, abstracted heads were drawn freely on its surface, where the dark brown over-glaze was scraped away to reveal the white clay beneath [cat. 66]. This technique was used on a vase from the same period, but enlivened with horizontal banding and division of the surface into a grid [cat. 65]. The result is a strange, primitivistic mixture of simple geometric motifs.

Numerous other bowls, vases, and lamp bases served as vehicles for abstracted linear designs which had their origins in late Sur-realist and Abstract Expressionist imagery. Ed admits influences of at least a general nature that informed this kind of linear decoration. "Especially in the period I went through with the handwriting, the 'Arabic' look, there were all sorts of reachings out in different directions. Karl Drerup (a German-born New Hampshire painter and enamelist, and fellow member of the League of New Hampshire Craftsmen) had an influence, not through his work but through his love for the work of Paul Klee," one of whose small paintings the Scheiers later acquired.[20] "He excited us about the work of Paul Klee, and some of that excitement can surely be felt

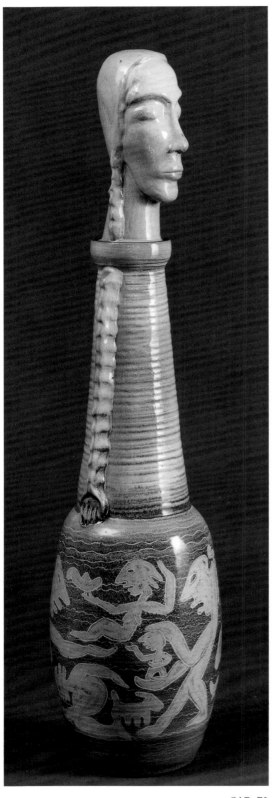

CAT. 71

in some of my attempts."[21] Klee's dreamworlds are obvious precedents for the lonely psychic stages on which Ed Scheier's human and animal characters play their curious roles.

Pre-Columbian pottery had an even more powerful influence on the forms, motifs, and even the decorative techniques employed by Ed Scheier on his ceramics of the 1950s.[22] Ed readily acknowledges in his later writings, in fact, his great admiration for Mayan art.[23] In 1953 during Ed's sabbatical year, Mary and Ed travelled to Mexico, working part of one winter with the archaeologist Franz Blom. They assisted Blom in whatever way they could on digs at various Mayan sites in southern Mexico, trekking by mule to remote locations in Chiapas and Yucatan.[24] The Scheiers returned to Mexico for a lengthy stay in 1958 on another sabbatical, developing a passion for its people, culture, and artistic heritage that would eventually result in their moving there in 1968. This direct experience of pre-Columbian art and architecture stimulated Ed to further explore the potential for figural decoration on essentially functional ceramic forms.

In a unique bowl dating from the early 1950s [cat. 97], for example, a plane of grotesquely distorted black-glazed heads and figures stand out almost in low relief against the lighter recessed background plane. Although the figures are to some extent connected to the Surrealist-inspired works of the late 1940s, their abstract and planar forms recall just as strongly the motifs and techniques found on Mexican-inspired Guatemalan bowls of the Early Classic period, where dark-ground figures, carved out against a lighter background densely fill a central horizontal band.[25] Sometimes Ed has borrowed only the form of pre-Columbian pots; in these instances [cat. 70, 72] he has employed the long, tapering neck and flaring rim found in Classic Period Colima hatchet-formed vessels.[26]

His best works demonstrate a thorough assimilation and essential transformation of his diverse sources. A tall, narrow-necked, three-part vase with lid dating from 1947 [cat. 71], for example, belongs to the family of works inspired by Colima hatchet-form vessels. Even

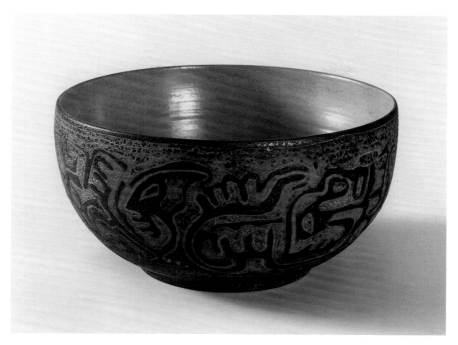

the elongated form and exaggerated features of the lid/head has its precedents in many types of pre-Columbian sculpture, especially those from Jalisco.[27] Yet the more vigorously sculptural applied decoration, particularly in combination with the energetic sgraffito drawing of figures at the bottom, is pure Ed Scheier. The figure's modelled braids hang down the sides of the figure's earnest-visaged head, then continue downward to become not just her arms but eventually her hands. Humor and surprise are within the piece's emotional spectrum, another departure from this vase's pre-Columbian heritage.

The covered jars made by Ed from the late 1940s through the mid-1950s bear many of these distinctive hallmarks, yet they possess another dimension in the sense they appear to have been made to serve some purpose beyond pure utilitarianism. In what is perhaps his finest covered jar [cat. 84, color plate, p. 21], pale yellow matte-glazed female figures are split in two vertically and contain within each of them a small child. The figures create a stoic procession around the jar against a somber, deep purple-brown matte glaze. The handle of the jar's lid is a smooth purple-glazed smiling female figure between

whose legs stands a tiny, pale yellow child. The sense of embryonic protection seen in the figures on the vessel is repeated in the handle, where the child is safely enclosed by the legs of its mother. These themes of protection are metaphorically implied in the type of vessel itself, where the lid serves to enclose and protect that which is placed inside the large womb of the jar. The use of such motifs makes these vessels appear to be implements for some unexplained, primitive ritual or ceremony.

Ed Scheier also employed other sculptural means of surface decoration. Building upon the applied low-relief decoration that he used in his earliest experiments with pottery [see cat. 11, 12], he gradually refined this expressive language. Encircling one masterful vase of the mid-1950s [cat. 89, color plate, p. 22], large, haunting figures are defined in part by applied tubes of clay and in part by sgraffito outlines. Dark brown Albany slip shows through the unusual pale green glaze, particularly where the figures dance their way around the vase. In an even larger vase of the early 1960s [cat. 90, color plate, p. 22], predominantly abstract low-relief decorations are woven densely in swirls con-

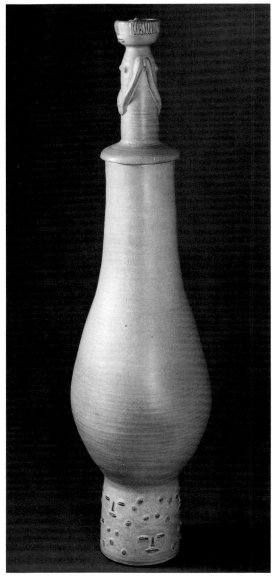

CAT. 70

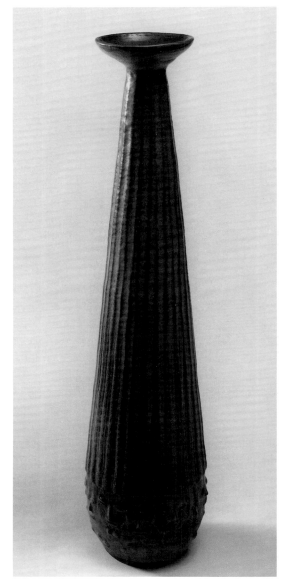

CAT. 72

tained within a narrow horizontal band of space at the pot's bulbous center. Both this concentration of decoration as well as the very form of this and other vases of the late 1950s and early 1960s recall Guatemalan pots of the Late Classic period[28], although Ed's pots are taller, less squat, and their decoration applied onto the surface rather than carved into it.

In the late 1950s and throughout the 1960s, Ed's decoration became even more aggressively sculptural, and was usually employed in combination with the sgraffito drawing techniques that he had been practicing for two decades. New motifs also appeared, almost always in large vases. For example, a cross-legged figure sits calmly within the open mouth of a fancifully drawn lion, whose teeth form, at the same time, the jagged edges of a mandala-like oval [cat. 102]. In another vase [cat. 103], alternating male and female figures stand or lie inside the bellies of fish who swim haphazardly over one another in a swirling, dark brown sea. The figures in both vases are drawn by scraping away the dark matte glaze from the central band in which the composition is contained. As in the previous work, the figures here seem content despite being trapped within another living being.

These large sculptural pots of the 1960s, in fact, seem to have been a vehicle for formulating a new theme of entrapment, although increasingly more psychic than physical. In one, figures alternate with large heads depicted only by eyes, noses, and mouths in low relief that protrude from the delicately flecked sgraffito surface [cat. 105]. In a further development of this theme [cat. 110], large smooth heads, pushed out from the surface from behind, face one another in profile. Surprisingly, as one moves around the vase, the eyes of the adjoining profiled heads form the eyes of another head whose open mouth, pushed inward, contains yet another figure whose eyes and mouth are all formed by three smaller heads. Such vessels, too, have their conceptual origins in pre-Columbian pottery, namely Colima pots formed by an entire head with an opening at the top, or by highly three-dimensional heads that encircle the pot.[29] The strong psychological impact of

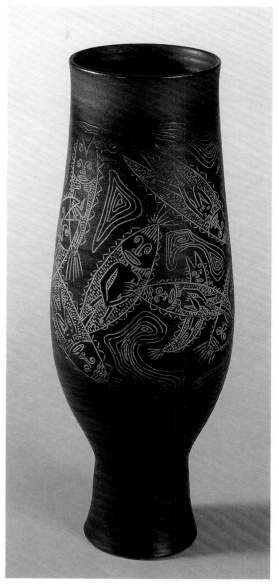

CAT. 103

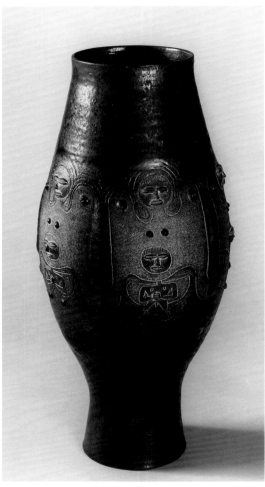

CAT. 105

Ed's vessels is all the more remarkable in that his works were created without the latent ritual function inherent to their Colima predecessors.

In what is probably the most exotic and haunting of these head vases [cat. 109, color plate, p. 23], exaggerated profiles simultaneously bulge outward and recess inward. Small, smooth half-spheres form not only the mouth of the head, but even its widely-separated eyes. Heads emerge, ghost-like, as if the vase were an abstracted cranial cavity. Moreover, in this and many of the large vessels of the mid-to late 1960s, a new and even more powerful expressiveness is exerted through new glazes Ed Scheier developed. Particularly in this last vase, there is a rough crater-like surface formed by the broken hemispheres of bubbling glazes. The figures' "skin" is in fact pocked with a bronze-gold, brown, black, and blue crater glaze. Through masterful manipulation of form and inventive use of glazes, the vessel has become merely the point of departure for a dynamic new type of ceramic sculpture.

The Scheiers spent more than two decades living and working together in Durham, producing an extraordinary range of pottery, developing the styles for which they became known. The utilitarian wares made jointly by Mary and Ed throughout their years in New Hampshire were among the finest of the period, thoroughly embracing modernist esthetics while at the same time relying on the venerable tradition of oriental ceramics. Ed also embarked on independent pottery-making ventures, creating ostensibly functional vessels whose decoration – and in the best examples, whose form simultaneously – carried symbolic meaning. His early borrowings from American folk pottery were succeeded in turn by his experiments with Surrealism and Abstract Expressionism, and eventually his deep interest in the expressive characteristics of pre-Columbian art in general, and its pottery in particular. While serendipity certainly played a role in the Scheiers' initial decision to become potters, their devotion, hard work, and keen intellects were constantly brought to bear upon excelling at their chosen craft.

1. For information on Campbell and the League, see Betty Steele, *The League of New Hampshire Craftsmen's First Fifty Years* (Concord: League of N. H. Craftsmen, 1982)

2. Komanecky-Scheier interview, January 17, 1992

3. Komanecky-Scheier interview, January 17, 1992

4. See *Selected Bibliography*

5. Gilberto Cruz Igartua, "La industria de cerámica ofreció un exhibición," *Puerto Rico Illustrado* (December 22, 1945)

6. These works by Prieto are now in the University Art Galleries at the University of New Hampshire, Durham

7. See *Selected Bibliography*

8. See *Museum Collections*

9. See *Selected Exhibitions*

10. Perry, *American Ceramics*, 157, cat. 196

11. See for example Michael Kan, Clement Meighan, H. B. Nicholson, *Sculpture of Ancient West Mexico* (Albuquerque: Los Angeles County Museum of Art in association with University of New Mexico Press, 1989): 52–53 and 90, catalogue number 33

12. Alfred Kidder II and Carlos Samayoa Chinchilla, *The Art of the Ancient Maya* (New York: Thomas Y. Crowell Company, 1959): 69, catalogue number 31. This monograph accompanied an exhibition that travelled to the Detroit Institute of Arts; the University Museum, Philadelphia; the Nelson Atkins Museum, Kansas City; the De Young Museum, San Francisco; and the Los Angeles County Museum of Art

13. For an illustration of some of these Hillcrock pieces, and some of the very earliest Durham pieces, see *Bulletin of the American Ceramic Society*, 266, 268–270; *House and Garden* (November 1943); and *Design* (December 1943): 12 and cover.

14. The Scheiers sold their work at their university studio, through the various shops of the League of New Hampshire Arts and Crafts (later the League of New Hampshire Craftsmen), and at the annual summer fairs of the League, at which the Scheiers showed their work almost every year from 1941 to 1968. From 1951 on, they sold work from their new combined home and studio in Durham, designed by their early supporter, architect David Campbell. Pieces were also frequently sold through America House in New York.

15. In an April 21, 1993, telephone interview, Otto Natzler stated that contrary to many published accounts, Gertrud did not attend any classes at the Kunstgewerbeschule in Vienna. Otto explained that she went to the school to see what classes would be like, but decided immediately that they were not for her and never returned. The Scheiers and Natzlers became acquainted in the late 1940s, when Ed met them in Puerto Rico as part of his work with the economic development project there. The Natzlers later stayed with the Scheiers in New Hampshire, and the Scheiers visited the Natzlers in California.

16. After a hiatus of more than thirty years, he would eventually return to experiment again with this form around 1990; see Chapter Six, *New Beginnings*.

17. Komanecky-Scheier interview, January 17, 1992. The Scheiers also became friends and traded works with Charles and Musya Sheeler. The Scheiers gave their pottery in return for photographs by Charles and by Musya Sheeler, now in The Currier Gallery of Art.

18. See Perry, *American Ceramics*, 182, cat. 243, 244 (Schreckengost); 127, cat. 143 (Atchley); and 132, cat. 152 (Brastoff)

19. See Edwin Scheier, "What is Art," *New Hampshire Alumnus* (March 1956), unpaginated. Reprinted in this catalogue, p. 86–89.

20. Komanecky-Scheier interview, January 17, 1992

21. For a reproduction of the untitled c. 1925 painting, see Peter Bermingham, *The University of Arizona Museum of Art: Paintings and Sculpture in the Permanent Collection* (The Arizona Board of Regents, 1983): 48, catalogue number 106

22. Elaine Levin, "Pioneers of Contemporary American Ceramics," *Ceramics Monthly*, vol. 24 (May 1976): 35

23. Ed Scheier, "What is Art," *New Hampshire Alumnus* (March 1956), unpaginated. Reprinted in this catalogue, p. 86–89.

24. Josephine D. Gilman, "World Famous Ceramists," *Worcester Sunday Telegram* (Feature Parade Section, August 19, 1962): 5; and "UNH Art Prof Attains World Fame In Ceramics Exposition," *The New Hampshire* (November 1955): 8

25. See Kidder, 53, catalogue number 14

26. Dore Ashton, *Abstract Art Before Columbus* (New York: Andre Emmerich Gallery, 1957): 8

27. Kan et al., 115, catalogue number 80

28. Kidder et al., 68, catalogue number 30. Eighteenth and nineteenth century American stoneware grotesque jugs are also conceptual predecessors to Ed's "face pots," although given his admiration for pre-Columbian art, they are far less likely to have influenced his work.

29. Kan et al., 137–138, catalogue numbers 124–125

CHAPTER FIVE: *Mexico*

THE SCHEIERS' YEARS in Durham were creative and happy ones. They solidified their national reputations, and the university environment provided them with an intellectually diverse community from which their growing circle of friends emerged. Their increasing financial success permitted them to travel more widely, and their growing status as artists afforded them the opportunity to participate in and jury exhibitions, and to attend ceramic conferences across the country. And, of course, there was travel simply for the enjoyment of it.

The place the Scheiers enjoyed most was Mexico. As a result of trips there in 1953 and 1958, the Scheiers fell in love with its ancient art and culture, the beauty of its landscape, and its inviting climate. The lure of the lush, remote province of Oaxaca was compelling, and after their retirement from the University of New Hampshire in 1960, the Scheiers spent every winter there. Eventually they bought a house and settled there in 1968, remaining in Oaxaca for the next ten years.

The move marked a critical change in the Scheiers' artistic endeavors. Up until that time, both Mary and Ed concentrated their prodigious energies on making pottery, Mary focusing on utilitarian wares and Ed on his increasingly sculptural vessels. In Mexico, the Scheiers wanted a house large enough for them to continue making pottery. Consequently they immediately added a large separate studio to the home they bought in Oaxaca. Yet in the end, they made little pottery during their years in Mexico. Due to her better knowledge of Spanish, Mary assumed the responsibilities of running the house, supervising carpenters, stonemasons, and other household workers, and negotiating their way when necessary through Mexican bureaucracy. Mary made some pot-

tery, but more as occasional experiments than anything else. Because of the eventual onset of arthritis several years later, her career as a potter was essentially over after thirty years of creative activity in which she had established herself as one of America's foremost studio potters. Ed, on the other hand, continued his work uninterrupted, and with a new penchant for exploration.

WEAVINGS

Contact with Mexico led Ed Scheier to experiment with new means and media. During their first trip to Mexico in 1953–54, the Scheiers came in contact with native craftsmen and women who for generations had made weavings using traditional geometric motifs. Seeing their work, Ed was inspired to make his own designs and arranged to have these weavers carry them out. His earliest works were cotton warp, woven in San Miguel. On a later trip in 1958, he arranged for three families of Zapotec weavers in Teotitlán del Valle in Oaxaca to weave his new designs, this time in wool warp and woof.[1] The weavings are larger in scale than any work he had yet done, and consequently their rich imagery has an even more immediate impact. Returning to New Hampshire after this 1958 trip, these weavings – which could serve as either wall hangings or carpets – were shown for the first time in a 1959 exhibition of his work at the Lamont Gallery at Phillips Exeter Academy in Exeter, New Hampshire.[2]

Over the next several years, and especially after the Scheiers moved to Mexico, Ed's designs were woven into hangings by these Zapotec weavers, who produced approximately seventy-five of them. The process for all was identical. Ed drew a full-scale cartoon on brown paper, plus a smaller sketch indicating colors to be used. The weavers then cut out the full-scale

FIG. 1. Installation of Ed Scheier's
1974 show in Oaxaca, Mexico

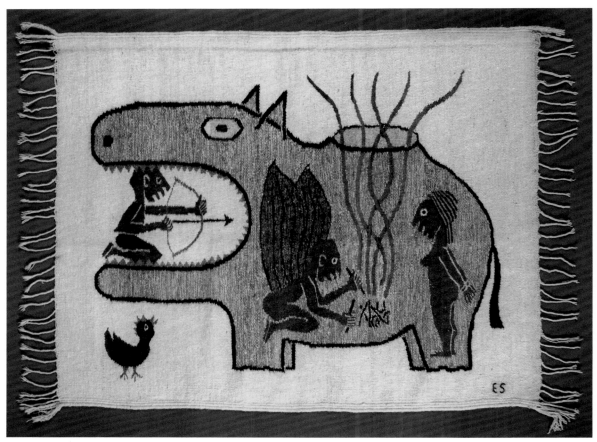

drawing to make a kind of stencil pattern for work on the loom. All the weavings were woven in the traditional serape technique, finished so that both sides can be used. Some, however, have embroidered highlights that are meant to be seen from one side only; most, but not all, carry an embroidered "ES" signature, often stitched by Ed himself. Natural dyes were used for the predominant black, brown, gray, and tan colors, while aniline dyes were used for the more occasional reds and yellows.

The subjects of the weavings are intimately linked to those in his pottery of the same period: entrapment, birth, and temptation. Smaller figures are subsumed inside larger ones, sometimes further entrapped within larger animals whose motivations are not readily evident. One weaving, for example, depicts a woman standing inside an open-mouthed lion with her outstretched hands being held by her male partner who squats on the lion's back [cat. 171, color plate, p. 25]. She is shown giving birth, her child emerging upside down from her invisible legs – into the open, jagged-toothed mouth of a smaller lion standing between the legs of its larger companion! Neither lion seems to pose danger; rather they strangely seem benign animal protectors of humankind.

In one of most unusual and humorous variants of this theme [cat. 165], a couple embrace passionately, surrounded by little fish inside the belly of a spouting whale. On closer examination one discovers that the woman's legs connect to the whale's tail; she is a most unusual lure. A mysterious scene takes place in another of these weavings [cat. 164], where a winged (angel?) figure lights a fire inside the belly of a large hippo-like creature. The fire warms a woman standing inside the creature, while smoke from the fire climbs upward, leaving through an oval opening just above. In the open-toothed jaws of the hippo, a male hunter

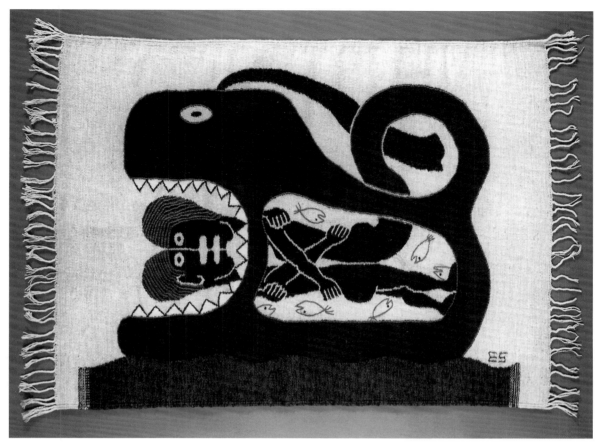

draws his bow, but his attention is diverted from his prey – the small bird on the ground below – to protect his partner from the peculiar and perhaps threatening goings on inside the hippo's belly. If there is a threat, it seems the threat of the new, even if only the gift of fire brought by the gods.

Ed Scheier's fertile imagination also focused on his ever-present interest in the subject of the temptation of Adam and Eve. The results are some of the most creative interpretations of this theme found in twentieth-century art. In one weaving, a black Adam sits inside the by-now familiar lion's mouth [cat. 168]. With a look of bewilderment and perhaps fright, Adam clasps his arms around the lighter-skinned Eve. She stands inside the lion's mouth as well, seemingly unperturbed by any threat, holding in one hand the tempting fruit, and in her other hand, the serpent's tail. Her strength provides Adam with comfort and protection;

the couple is oblivious of what the future may portend. In another weaving [cat. 167], Adam, seemingly caught inside the jaws of the lion-serpent, is holding (thrusting?) an immense apple beyond the creature's grasp. Inexplicably, the apple contains Eve herself – she is the fruit of temptation: both temptation itself as well as born of it.

In another even more original variant [cat. 170] of this theme, a black Adam holds in one hand the tempting apple, the threat of which is evident from the little serpent that awaits inside. In his other hand, Adam holds Eve's head, grasping onto a lock of her hair as if it were one of the handles of Ed's covered jars – a visual pun on his own work as a potter. Yet from her neck an entire branch full of apples emerges, the branches serving as her arms and legs, gently caressing her partner. Here, Adam and Eve tempt each other.

A rare presentation of the expulsion has also

found its way into one of the large-scale weavings [cat. 166]. Eve, who holds the apple in her hand, walks with Adam, their backs turned to a threatening serpent. By succumbing to temptation, they seem literally to have been forced from an overturned nest, from which four eggs have likewise tumbled out onto the ground. The serpent's forked tongue reaches out toward the departing couple, but a flying bird grasps the serpent's neck in its beak, arresting the serpent's threatening gesture. At the far right, the large hand of God extends upward – has it tipped the nest or is it holding it up? Is the nest the figurative nest of Adam and Eve, or the literal nest of the bird? Or is it the serpent's? Or is it the nest in which all young life is nourished? Many readings of this spiritual allegory are possible, all rich with meaning about our origins and nature.

MIXED MEDIA WORKS

In 1960 and 1961, following his retirement from the University of New Hampshire, Ed and Mary spent nine months in Spain, living mostly in a rented house in Fuengirola, near Malaga. There, Ed prepared a small number of pastels, one of the best of which again portrays the expulsion of Adam and Eve [cat. 154, color plate, p. 24]. The larger-than-life hand of God, raised upward, forces the couple from a cave-like garden of Eden, where flowers cover the ground and a tree with green apples fills the entrance. The couple flee toward a setting (or rising?) sun, Eve's hair blown back with the speed of her flight. In her hand she holds a green apple plucked from the tree of knowledge. The most unusual aspect of the scene is that Adam, his arms aloft, pulls in the air above him a red-

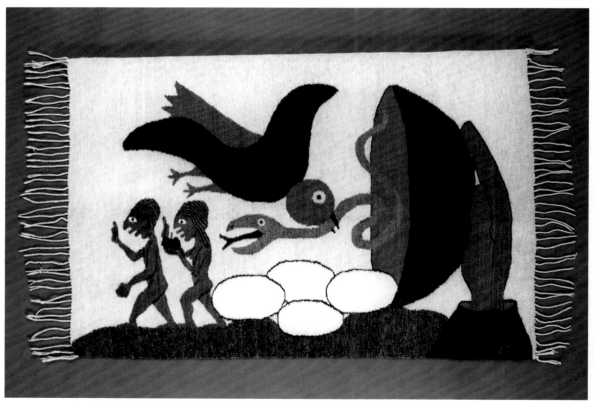

CAT. 166

74

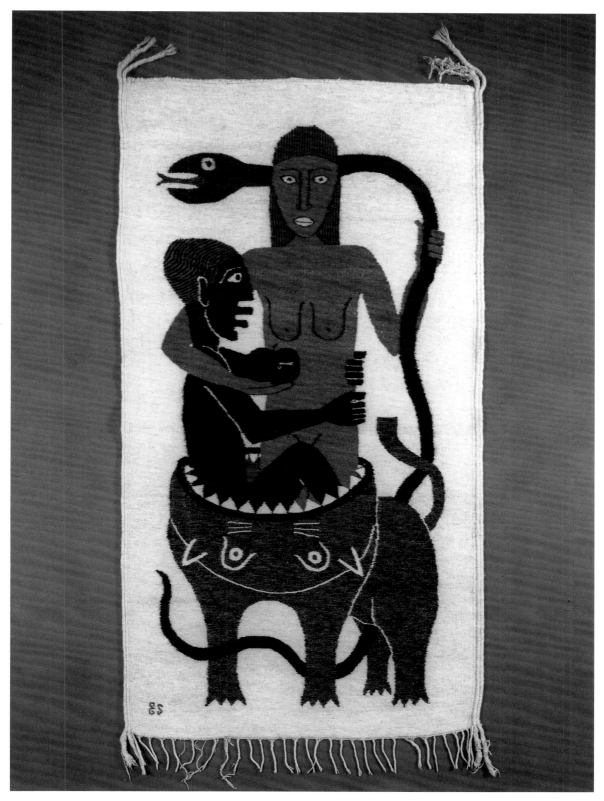

skinned female figure whose hair is also flung back; her hair stretches further and further, outlining with its black color an eerie landscape filled with trees, birds, and flowers.

In this unorthodox depiction of the expulsion, Adam and Eve have been forced from their paradise as a consequence of their disobedience to the laws of God. But who is the woman above Adam's head? The red skin would imply she is a devil – the devil of temptation and lust that is inside all of us – brought by Adam into the world. Indeed, Eve chases Adam, and neither she nor the apple capture his attention any longer; he already has what he wants. The landscape inside this she-devil's head may be either the memory of paradise lost or the dream of paradise, if not found, at least hoped for, even in the face of evil.

Repeatedly Ed has been drawn to the subject of the temptation and, less frequently, the expulsion of Adam and Eve. Ed's preoccupation with these themes cannot be explained by the influence of either contemporary American or European art[3] – the theme was virtually ignored – or by that of the great Christian iconographic tradition of earlier centuries in which comparable treatments cannot be found. His obsession certainly does not emanate from any personal religious convictions, for although born of Jewish parents, Ed never practiced Judaism and, in fact, rejected any connection with it from an early age. Rather, the stories of Adam and Eve appeal to him because they offer opportunities for examining human behavior, and even the nature of God, in a more universal sense. The sources for these various thematic presentations ultimately lie deep in Ed Scheier's psyche, a psyche that he prefers not to investigate too deeply other than to give it a place to be expressed, in his art.

In addition to making a small number of ink drawings and woodcuts after moving to Mexico, Ed did a series of works on paper in which he experimented with unusual combinations of media. Although he painted a few Pollock-inspired abstractions in the late 1940s, the medium never really interested him. When he and Mary settled in Mexico, first temporarily

in the early 1960s and then permanently in 1968, he sought new ways to make two-dimensional images that eventually involved a kind of painting. For these images he began by carving a relatively large-scale wood block and printed its bold, linear design in black ink on Japanese mulberry paper, thus defining the major outlines of an image. Ed would then brush hot wax onto certain areas of the paper which would be used to retain combinations of sand, small-grained pebbles, and powdered pigments sifted on from above. The paper rested on a heated metal plate, forcing these materials to become infused into the wax. Frequently, Ed would work the surface further, and the paper was eventually mounted on a thin plywood board. Consequently, the finished product is neither entirely a print nor entirely a painting, but is perhaps best considered a highly manipulated monotype. During the 1970s and into the 1980s, Ed Scheier produced more than one hundred of these mixed media works, almost all of which he had framed with native Mexican woods.

Many were done contemporaneously with the weavings, and consequently there is a close correspondence in thematic subject matter. A new iconographic variant of Adam and Eve appears [cat. 153] in which a blue-skinned woman with long dark hair is shown bust length. One of her arms stretches diagonally across her torso, attempting to cover her naked breasts, and her other arm reaches horizontally across her waist. In her hand stands a pale-skinned boy who, with one arm around the woman's neck, holds an apple in his hand. The image recalls late medieval and Renaissance representations of the Madonna and Child, in which the Christ child holds an apple or pomegranate as a symbol of his role as the new Adam. While the iconographic sources may rest in European art of the fifteenth and sixteenth centuries, this Madonna's stylized features recall primitive African art and even Egyptian portraiture of the early Christian period. In this unusual combination of iconographic and stylistic heritages, the message focuses on the warm and tender relationship between the God-mother and God-child.

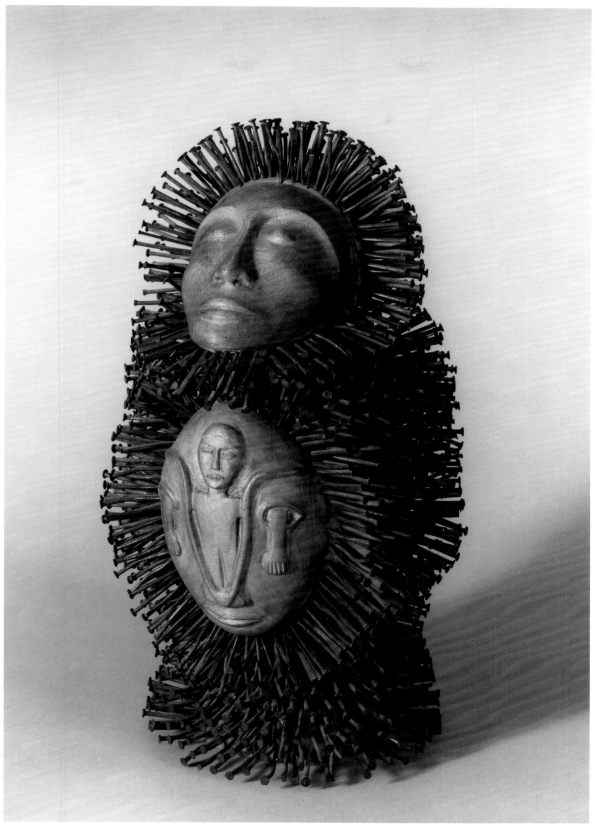

Attracted by the beauty and carvability of guanacastle, a wood native to Mexico, Ed returned to a medium and material he first experimented with in 1917 while still a young boy. He admired the large wooden bowls in which natives ground grain, and he occasionally bought some of these bowls to carve and make sculpture from. He found the wood easy to carve and eventually, to make still larger sculpture, selected tall, thick boards. Paint, sand, nails, or jute rope were frequently used either alone or in combination to adorn the approximately one hundred fetishistic figure sculptures that he made in Mexico between 1970 and 1978. Although he also made several stone sculptures in this period, wood was his preferred medium. The sculpture, too, is an extension, physically and thematically, of his lifelong interest in figural forms inspired by primitive cultures. It is consequently intentionally far removed from virtually any movements in contemporary western sculpture, with the exception of similarly conscious primitivisms in European and American art of the early twentieth century.

One of the earliest and most dramatic of these sculptures [cat. 178] shows a figure with a carved, upward-gazing wood head, whose torso, neck, hair, and even skin are composed of hundreds of nails pounded into the wood core. The armless body, full of austere restraint, stands legless on its gently splayed trunk of nails. From this figure's exposed torso appears a face in whose nose there is actually a small figure, standing upright and with his arms emerging through the eyes of the head. This odd juxtaposition of heads and faces is a radical departure from the nature and surface quality of Ed's clay sculptures of the late 1940s and the clay sculpture-pottery of the 1950s. Its precedent is almost certainly in the nail-encrusted Vili or Yombe fetish figures of Africa that western artists emulated throughout the twentieth century.[4] The art of the South Pacific, too, has found its way into Ed's work. An early wood piece in which a man and woman are protected

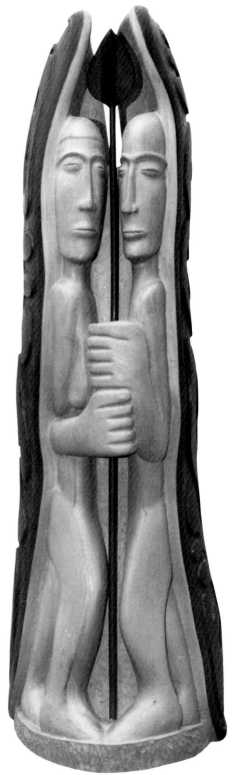

CAT. 182

by the carved shields that surround them [cat. 182] is similar to Asmat shields from the Lorenz River in Irian Jaya (formerly Netherlands New Guinea).[5] The Scheiers became familiar with the art of New Guinea at least in part from Sepik River masks given to them by friends in trade for examples of their pottery.

Most of the wood sculptures examine themes of birth and generation, occasionally enlivened with tame but humorous depictions of couples' sexual encounters. In one [cat. 180], a man and woman embrace each other while their progeny has already emerged, upside down, outside the body of the spread-limbed lion that surrounds them. The effect of this table sculpture depends on the contrast between the seductive color and grain of the smooth-surfaced wood, and the red-tinged, jagged-toothed, deep recess of the lion's mouth in which the couple stands. In one of the tallest wood sculptures [cat. 174], a nearly eight-foot high female figure stands erect, her long jute-rope hair partially covering her breasts. There is a tiny figure in her recessed and roughly carved womb. She is intertwined with a smaller upside-down male figure whose head peers out at us from between her legs. Such intertwinings [see also cat. 175, 176] reinforce the notion of humankind's intimate dependency upon itself for protection, nurturing, even its very survival.

The subject of many of these sculptures, first portrayed on numerous ceramic works of previous decades, constitutes another primary theme of Ed's work: family. Mothers and children stand stoically or dance around bowls; embryos rest safe within their mothers' wombs; small figures are symbolically protected by their larger female companions. Notably, most often mothers and children are shown together, with fathers conspicuously absent. As universal as these representations may be, they also reflect the circumstances of Ed's own fatherless youth. In addition, Mary and Ed did not have children, but Ed in particular seems to have been driven to give birth to a family of offspring in the objects he created and especially by virtue of the imagery found on them.

Taken as a whole, the years in Mexico from 1968 to 1978 signaled an unexpected departure in Ed Scheier's development as an artist. Having devoted three decades of his life to making essentially utilitarian although inventively decorated pottery, he abruptly changed course to venture into other media. He virtually ignored pottery, despite having built a pottery studio in Oaxaca. The challenges of working in these new and different media – weavings, paper, paint, and wood – became a new contextual framework for exploring fertility and temptation themes that are central to his own psyche. The weavings, by virtue of their large scale and simple narrative, are consistently the most successful of all these new works. The works on paper provided the freest rein for Ed's visual imagination and technical improvisations, while the sculpture, the most idiosyncratic of his work, offered an opportunity for him to develop further his language of three-dimensional forms on a still larger scale.

1. Komanecky-Scheier interview, April 12, 1993, and William Hutton, "Edwin Scheier," *The Currier Gallery of Art Bulletin* (September – October 1966). This issue of the Bulletin containing Hutton's unpaginated essay served as the catalogue to the Currier's 1966 exhibition of Ed Scheier's work.
2. See *Selected Exhibitions*
3. See Scheier, "What is Art," p. 86–89
4. See William Rubin, editor, *"Primitivism" in 20th Century Art, Volume 1* (New York: The Museum of Modern Art, 1984): 57 and 67
5. See Rubin, 62

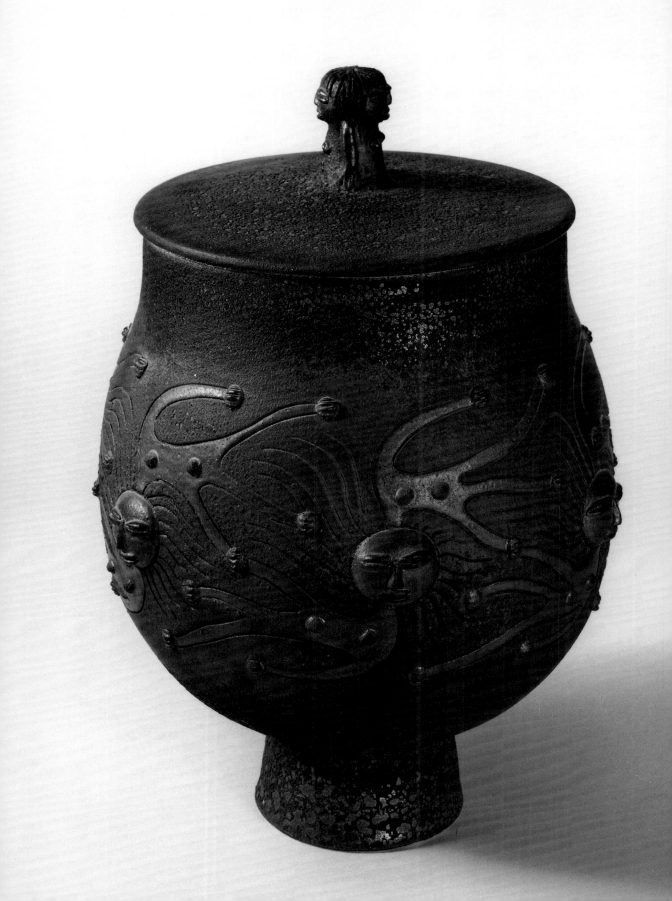

CHAPTER SIX: *New Beginnings in Arizona*

EVER SINCE first visiting Mexico in the early 1950s, the Scheiers had become deeply attached to the culture, climate, and the art of their adopted home. They traveled extensively throughout Mexico, visiting archaeological sites as well as the country's great museums. They bought a beautiful home in the mountains of Oaxaca, adding a spacious studio and expanding the site's luxurious gardens. Although both Mary and Ed made little pottery while living in Oaxaca, Ed discovered a new-found freedom to explore artistic alternatives. After spending most, if not all, of every year for nearly two decades in Oaxaca, however, Mary and Ed began to consider seriously whether they should return to the United States. In practical terms, they had enough experience with Mexican bureaucracy to know that dealings with the health-care community could be complicated, especially in as remote a place as Oaxaca. In a broader sense, they felt it was time to come home. Although not without some reluctance, they opted to move back to the States. They wanted to settle in a place where the climate would be as hospitable as that of subtropical Oaxaca, or at least nearly so. New Mexico and Arizona were both attractive from this point of view, and in 1978, the Scheiers bought a home in Green Valley, Arizona, south of Tucson, where they have lived ever since.

They added a studio to this new home to accommodate their artistic needs, but for two years after moving to Arizona, although his health was robust, Ed lost some of his passion for making pottery. Compared to his habits in New Hampshire, he produced little – a considerable change for an artist whose prodigious work ethic was born of the poverty of his youth and hardened by the Great Depression. This period in Ed's career was not without difficulty, in fact, and brought about a personal reevalua-

tion of his life and work. Driven to express himself through his art, however, he gradually returned to the studio. His passion to make pottery rekindled, Ed also received support from the art world's growing interest in his and Mary's works of the 1940s, 1950s, and 1960s. The Scheiers' early pieces were increasingly being sought after, bringing prices that astounded them when compared to the very modest prices for which they had originally been sold.

In 1982, Fifty/50 Gallery in New York, in cooperation with the Scheiers, mounted a small but important exhibition of their pottery, weavings, sculpture, and works on paper.[1] The show was accompanied by a modest catalogue that contained exquisite black-and-white photographs of the works taken by Robert Mapplethorpe. The exhibition served several purposes. It reintroduced the Scheiers and their work not only to those who had known their vintage New Hampshire pottery, but also to a growing number of new collectors who were learning the talents of this creative husband-and-wife team. In addition, Ed included several new works in the show, beginning what has become an uninterrupted, decade-long stint in the studio devoted exclusively to making pottery.

PLATTERS

In 1991, Ed produced a series of approximately seventy-five round platters, similar in dimension and shape to those that he had done between the late 1940s and the mid-1950s. Familiar themes involving the story of Adam and Eve predominate. On the surface of one platter [cat. 118, color plate, p. 26], Eve grasps at the tempter serpent, who holds an apple in its mouth as its body twists around her, intertwined in her own hair. What is new here is that she calmly sits upon a large outstretched hand of God, which symbolizes here a more protective and

FIG. 1. *Covered jar with figure design,* 1989 [cat. 124]

supportive God than in earlier depictions. Also new is that both Eve and the hand of God exist solely inside an even larger head that takes up most of the platter's surface. Although Ed previously employed the motif of figures within heads, its use in this context suggests that Adam and Eve's drama of temptation and protection, and apparently its moral lessons, exist literally as well as figuratively in our own heads. All of these new platters, whether portraying stories of Adam and Eve [cat. 113, 114, 117–120, color plate, p. 26], familial themes [cat. 112, 115], or nearly abstract figure patterns [cat. 116], are marked by new approaches to color and glaze. Rich and varied shades of blue, ranging from light, almost turquoise to deep royal blue, are complemented by pale or dark maroons. In addition, the decorations are etched more deeply and with broader lines than in the earlier platters, revealing a harmonious grayish stoneware beneath. The glazes also vary richly: velvety matte surfaces contrast with relatively soft, slightly iridescent crater glazes.

Bowls

Between 1989 and 1993, Ed also made hundreds of vessels: bowls, jars, and covered jars that display a new, more sculptural grammar within his own decorative language. He successfully developed new shapes for his recent vessels: bowls can be low or high, they may have nearly straight sides or gently tapering sides, or they may even be exaggeratedly bulbous and decidedly squat. The bowls tend to be large, with vigorously manipulated surfaces and simple decorative themes, enhanced by new, inventive glazes. Figures float inside a band of heads that encircles one of these bowls [cat. 123]. Both the large and the small heads deform the surface with their convex and concave shapes. This "head-band" is set off by a medium maroon glaze that contrasts with the velvety gray and deep blue glazes in the upper and lower portions of the bowl. Even the interior of some of these bowls is decorated: figures have been drawn on the bulging surfaces where the bowl has been pushed inward or outward

[cat. 136, color plate, p. 28].

Where these more sculptural effects are absent, pure sgraffito decorations in combination with dramatic contrasts of glazes produce powerful effects. A dramatic iridescent bronze-gold glaze highlights dancing, suggestively gesturing female figures against deep gray and black manganese underglazes [cat. 125]. Other pieces have subtle glaze-decoration combinations, as in a bowl [cat. 131, color plate, p. 28] on which a joyous procession of mothers and their womb-children are depicted alternately upside-down and right side up, joined compositionally by the undulations of their wavy hair. Both drawn and modeled into the surface, these figures blush with color from a slightly iridescent pale-mauve glaze that matches the smooth texture of the surrounding grays. This elegant harmony is interrupted only by a controlled burst of deep burgundy underglaze at the very bottom of the bowl, just above its foot. The crater glaze is utilized prominently for the first time since the 1960s. In one bowl [cat. 138], its use is concentrated above and below the more smoothly glazed band of figures, serving simultaneously to emphasize the decorative scheme and to lead the viewer's eye from top to bottom, ultimately drawing attention to all aspects of the bowl's form, surface, color, and decoration.

Jars

Some of Ed Scheier's new pots are difficult to classify, hovering somewhere between the categories of bowl and vase, and perhaps best described as jars. In one example [cat. 126], the jar's tall sides gently splay outward, rising upward from an exquisite dark gray, slightly bulbous bottom. The decoration consists of an ingeniously interwoven pattern of standing and seated females, articulated by deep sgraffito outlines and wavy hair, as well as by spherical projections from the surface that define the figures' heads. A luxurious bronze-gold crater glaze, confined to a band around and including the figures, contrasts sharply with the mysterious deep-gray matte colors below.

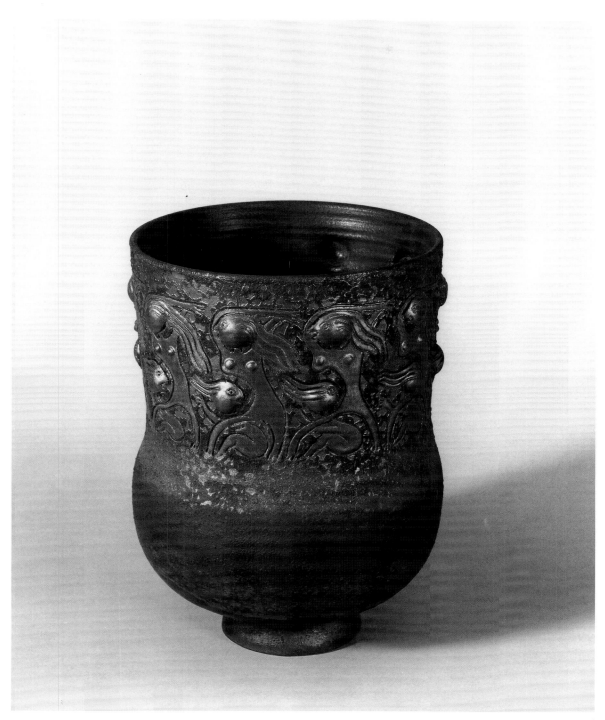

cat. 126

The same glaze treatment is found on another jar [cat. 144] whose decorations are among the most aggressively sculptural of any of Ed's recent work. Large concave sgraffito-outlined ovals form a horizontal band around the upper half of the jar, and between each oval a tall rectangular depression pushes deeply into the surface, further articulated by sets of undulating vertical lines. Together, the rectangles and ovals form a strong shape pattern that is enhanced by the juxtaposition of a dramatic bronze-gold overglaze and a somber gray underglaze.

The jar's figures are more than just decoration, however, and reveal an intriguing psychological tale. Each of the ovals contains a female figure trapped in a stock-like restraining device, and from a hole in the center of this stock, a small head protrudes. This particular thematic variant of entrapment, in fact, appeared first in a clay sculpture of the late 1940s depicting Adam and Eve [cat. 78], trapped by their own submission to the serpent's temptation. In this new work no serpent is present. The child-head emerging from behind the stock – and presumably from its mother's womb – suggests, in contrast to the earlier depiction of Adam and Eve, that regardless of how humanity finds itself restrained, new life, with its own sense of freedom, continues to evolve.

Ed's covered jars are perhaps the most daringly sculptural of all of his new work. As was common in the late 1940s and early 1950s, the jars' handles are actually fully sculpted small figures. Sometimes the three-dimensionality of the tiny figure-handles contrasts with the relatively two-dimensional treatment of the jar's overall decoration [cat. 124], but in some instances [cat. 139, color plate p. 27] there is a remarkable confluence of form, glaze, and decorative scheme. Here, a flat lid with a modeled female half-figure handle overhangs the upper rim of a bulbous jar. Running across the center of the jar is a pattern of alternating female figures and heads. The figures stand upright, legs spread, surrounded by energetic lines that either depict their long, wavy hair or simply fill voids in the decorative band. These figures are unsettling in that their roundish heads, pushed

deeply into the surface of the jar, have no features: no eyes, no noses, no mouths. Instead, they hold, in their arms above their featureless heads, another head, formed by having been pushed outward from inside the jar and complete with all the necessary orifices. In the spaces between these figures, mysterious heads, as large as the figures are tall, stare blankly, with their round eyes and long noses protruding outward from the surface. Their mouths are formed by deep, round recessions into which fully-featured heads, identical to those held high above by the figures, peer out at the viewer. The pattern mitigates some of this covered jar's unsettling psychological qualities, but its power ultimately derives from its metaphorical associations: although the piece is ostensibly a jar, it also seems to be a ritual cranial container whose contents we dare not explore.

CONCLUSION

Mary and Edwin Scheier, through their joint and individual creations, have made important contributions to the development of American studio pottery. Their decorated vessels of the early 1940s, thrown by Mary and decorated and glazed by Ed, as well as each of Mary's and Ed's small-scale figures, tentatively integrated techniques and imagery of American folk pottery with the formal language of American Social Realism. In doing so, the Scheiers carved out a stylistic niche at an early stage that distinguished them from their contemporaries. This tendency to combine and transform various sources became a hallmark of their careers.

The Scheiers' elegant utilitarian ware, thrown by Mary and glazed by Ed, set a standard for American ceramics at mid-century that was met by very few studio potters: Gertrud and Otto Natzler, Laura Andreson, and to a lesser extent Robert Meinhart, Laura Paddock, Stephen Polchert, and Rupert Deese. The success of the Scheiers' utilitarian pottery must be ascribed largely to Mary, who possessed formidable talent and discipline at the wheel. This work, produced as early as the 1940s but primarily in the 1950s and 1960s, reveals how

effectively Mary infused Chinese and Japanese forms with the modernist esthetic of postwar America. Having first been trained in New York and Paris as a painter, she brought to her pottery an acute sensitivity to form as well as an eager appetite for art of all types and periods. Although she unquestionably produced a nationally significant body of work in her thirty years as a potter, one can not help but imagine what she might have gone on to make had she continued to pot after moving to Mexico in 1968. It should also be remembered that in addition to creating her own body of work, she threw many of the small and moderate-sized vases and bowls decorated by Ed that helped establish his reputation.

Ed Scheier, by dint of his uninterrupted artistic activity as well as his idiosyncratic albeit inventive approach to ceramics, has an even more significant place in twentieth-century American pottery. His brief apprenticeships in the studios of Peter Mueller-Monk and Valerie Wieselthier gave rise, even if unconsciously, to a pronounced disposition for the sculptural possibilities of otherwise functional vessels. On occasion, he also inventively used clay as a medium for pure sculpture. Blessed by a keen, inquisitive intellect unhampered by the lack of formal education, Ed was continually inspired by the expressive potential of other art forms, periods, and cultures. From the beginning, he integrated ideas from diverse sources, first Social Realism, then virtually simultaneously Surrealism, Abstract Expressionism, African sculpture, and especially pre-Columbian pottery of Mexico and Guatemala. Although Peter Voulkos is generally credited with bringing the language of Abstract Expressionism into American ceramics,[2] there is ample evidence that Ed Scheier preceded Voulkos in this experiment. Voulkos has, in fact, acknowledged to the Scheiers personally how much he was influenced by their work of the 1940s and 1950s.[3] Ed brought to his art-making a deep curiosity about the human condition, and developed the ability to articulate his vision in several media, most successfully in his ceramics. There his figural decorations, focused on simple themes of temptation, fertility, and parenting, provide glimpses into the world of the psyche, sometimes humorously and other times earnestly. His ventures opened up stylistic, iconographic, and conceptual avenues for other potters to traverse, beginning with Voulkos. Voulkos, however, unquestionably reached a wider audience by virtue of his infectious teaching methods and the ability to inspire pottery students at Otis Art Institute and then the University of California at Berkeley. The Scheiers did not have this kind of opportunity at the University of New Hampshire. By all accounts, the Scheiers' were widely admired as teachers, giving their students an enthusiasm for making as well as collecting pottery, but the University simply did not attract very many serious art students.

Together, Mary and Ed Scheier's work has been astounding in its richness, breadth, and integrity. In retrospect, looking at their output over more than a half-century, it is sometimes hard to believe that they were both self-trained as potters. Both of them would assert that learning the way they have, by trial and error, and from the works of others that they encountered by chance or sought out by choice, has been to their advantage. Regardless of the nature of their apprenticeships, their mature works place them among the very best American potters of their time. In their half-century of life and work together, their legacy consists of the handsome works in clay they created, visual reminders of the warm, generous, and inquisitive spirits that brought them forth.

1. See *Selected Exhibitions*
2. Garth Clark, "American Ceramics Since 1950," in Perry, *American Ceramics*: 200–210
3. Komanecky-Scheier interview, January 17, 1992

What is Art? BY EDWIN SCHEIER

A lecture delivered at the senior thesis course "American Civilization in Transition" when Edwin Scheier was an Associate Professor in The Arts Department. (Reprinted from the March 1956 issue of The New Hampshire Alumnus)

ART, LIKE LIFE, seems to escape definition, but I should like to try to work toward what I feel art essentially to be. I am afraid I will get into this way over my head, as I am not a theorist but a practitioner – but it may be worthwhile to set down a few things that as a practitioner I happen to find are valid for me.

First, art is a human activity – an individual human activity. That means that no matter how beautiful a sunset or a flower may be it is not art.

Art is principally an expression of feelings, or an objectification of feelings in some material form and under certain conditions.

There are many ways that feelings can be objectified. As for instance, a man may express his anger by putting his fist through a pane of glass. Why is the pane of glass not a work of art? Because, while the broken glass shows the effect of the man's feelings, it does not in itself embody the quality of those feelings, and this embodying of the quality of the feelings is an essential condition of a work of art.

Let me define a work of art as an object that has been formed as a result of the process of the expression of human feelings, that then exists in its own right, independent of the artist who formed it. It, the work of art, takes on a life of its own which reflects and embodies the qualities of the feelings of the man who made it.

This is too simple a definition for a number of reasons. First, while I want to stress the primacy of feeling in art, feelings are never pure, they are more likely to be feeling-idea complexes. Generally speaking, both the making of art and the experiencing of art by the spectator is an emotional activity rather than an intellectual one. I do not think art is a vehicle for expressing ideas. While ideas are often the content of a painting or a piece of sculpture, the artist is expressing how he feels about an idea rather than the idea itself.

Second, it isn't likely that the artist starts

with a clearly defined feeling or concept, then selects an appropriate medium and translates his feeling into a material form. It is more likely that the artist starts with a vague feeling-state, an intuition, and only in the course of the process of working does it develop and clarify itself, and the developing and clarifying in the process with the resulting surprise, when the work is successful, are the source of the great excitement and even exaltation the artist often feels while creating, and which the spectator senses as one of the qualities of the work he has been experiencing.

I mentioned that a work of art exists in its own right, takes on a quality of life. Let's try to explore that further, and see if we can pin down some of the conditions and attributes of this "life."

The artist achieves his expression through sensitively conforming to the nature of the medium in which he is working. This is his means, his discipline: the painter through the relationship of colors and the arrangement of shapes, the sculptor through the relationship of masses, planes, volumes, etc. In any work all the elements, colors, shapes, are interrelated. They cohere to form a unity which has a value greater than the sum of these elements.

This magic ingredient, this quality of life that infuses the work and makes it add up to more than the sum of its parts, that gives it its peculiar quality, is often called the form of the work. It might also be called the will or the spirit of the work.

Now, while this life or vitality is a necessary part of a work of art, it is not all that we expect from it. Another ingredient is a reflection of the artist's sensitivity to his own feelings, to the world around him, and to the demands and nature of the material in which he is working. This ingredient could be called sensibility.

Another quality we look for in a work of art is vision, a new insight into that phase of the experience with which the artist is concerned. And if it is a meaningful work, we look beyond this particular phase of experience into its universal implications. I ought to say here that the artist himself is not likely to be concerned with the newness of the insight or to strive for a unique effect. The source of a work of art comes from some deep center in the individual the artist is. And I don't mean by this that the artist is a unique individual and that other men are less likely to be unique, but that all men at this level are unique.

If the artist is sincere in the expression of these feelings, even though similar feelings are the common experience of millions of men, the resulting expression will of necessity be a new insight, a unique statement. Each man's center is as different from that of all other men as his fingerprints are.

If all works of art are individual, what then would make the work of one artist greater, more meaningful, than the work of another? If we presuppose facility, and control of one's medium, it would mean one artist had feelings of greater depth, had broader vision, and had a need to find universal implications beyond the particular.

Art is a language, a means of communicating the stirrings inside one individual to others who can find some point of contact through their conscious or unconscious experience, or even beyond that to some intimation they have of a remote common experience. It is difficult to explain our response to some symbols on the basis just of our own individual experience. It is as if there were some thread that ties us to the family of man, past, present, and even future, to what the psychologist Jung calls the "collective unconscious."

To be sympathetically moved by a work of art one must have some of the same attributes that originally moved the artist. I believe the key attribute is a sense of the wonder and mystery of life and of the world, a sense of the

drama and adventure of man's passage through life. Art is an interpretation of and an exploration into these mysteries, into this adventure.

In the 10,000 years or so that we have had some record of man's experience on this earth, his ideas and knowledge of life and of the world have undergone many changes and developed enormously, but his basic feelings, the feelings of love, and fear, and hunger, and wonder, seem to have changed little. And while the expression of these feelings through art changes from culture to culture over both time and space, there is no growth in the essential quality of these expressions that parallels the great growth and refinement in man's knowledge and control of the physical world.

While we can learn much about a people by examination of their art, about their civilization and hierarchy of values, their religious and magical beliefs, there is no direct relationship between the degree of their civilization and the quality of their art. The quality of the Stone Age cave paintings in Spain and France cannot be considered any less than the work done now, simply because the basic feelings of these people were not any less intense or sincere than the feelings we have now.

While an understanding of the background of a culture is a great help in the comparative study of the arts of different people, our response to any work of art is not contingent on that understanding. We can respond to the life and wonder of a work of art even though we know nothing at all about the people who made it. As just one example, we are moved by the sculpture and architecture of the early Mayan people and know almost nothing about them.

The fact that our feelings are not too different from men who lived in remote times and in distant places makes the work they created just as much alive to us today as any made in our own time. It is this timelessness and eternally human quality of art that gives a sense of continuity to the drama of man's life on this earth.

There is a great range to man's experiences and a great variety of man's feelings and responses, and there must be a corresponding variety to man's expression of these experiences through art.

Man lives on many different levels, and one of the values of the visual arts is that it often throws light on some of the experiences that are hardest to express through the use of words.

Many modern artists, as well as psychologists, are concerned with man's inner life and with the stirrings in man's subconscious.

The artist feels it is just as natural and as valid for him to use as the content of his work symbols and expressions of man's inner life as it is to use elements of the natural, recognizable world.

The people who condemn modern art for its obscurity, who are uneasy in the presence of a work of art that does not imitate nature or represent nature in its most obvious recognizable forms, would limit art and the function of the artist to depicting that part of the world which is already a comfortable part of our knowledge and experience. One of the great values of art is the need of the artist to restate, in terms that are more meaningful to him, his experiences, to explore beyond and below the accepted answers to the questions raised by man in his need to find himself and relate himself to the world.

We often hear the question, "Why, if the artist is interested in communicating feelings, does he not use terms that are readily recognizable, so his communicating will be effective to great masses of people? Why does he not deal with real things that we can all understand?"

I'm sure that most artists would like to be understood by and even to have the approval of large numbers of people, both because they would like to feel they are a functioning part of society, and because it would help them earn a living through the sale of their work. But in the course of his creative work I do not believe the artist can be too conscious of the possible ultimate public audience. If, in his work, he takes one course rather than another with the thought that the course he has chosen will interest more people or win approval from one particular group or class, he cannot help but lessen the intensity of his work. This is the principal difference between the art I have been talking about and the commercial and propa-

ganda art we are all familiar with.

While the serious artist works from an inner need, a compulsion to express his feelings and intuitions, the commercial artist plans his work with the express purpose of interesting, convincing, or even seducing the greatest number of people. All such conscious catering to the sentimentality, the prejudices, the vanity of a people, or the furthering of a cause, good or bad, through art destroys the integrity and universality of the work of art.

The complaint, that the modern artist does not deal with reality in understandable terms, is the same charge made against Rembrandt, El Greco, Van Gogh, and many other artists in their time.

There are levels of reality, as there are levels of truth. Some people will be satisfied that they understand the reality of a tree by just the description of its outward appearance. Others will feel they have a deeper understanding of its reality if in addition to a description of its external appearance they have a sense of its organic growth, even though this sense may have to be conveyed in tems of symbols that express what is verbally unexpressible rather than by obvious visual facts.

One of the trends in modern art, as in much of earlier art, is the search for a deeper sense of reality, truths beyond the truths of facts alone. This often takes the form of reorganizing the elements of the natural world to suggest the inner nature, the inner structure of things; an example would be paintings of Cézanne. Another direction is presenting images that relate to states of mind rather than to external appearances. Many of the non-objective painters could come under this heading. Another is distorting natural forms to intensify the emotion that is being expressed. In this instance El Greco or any of the modern expressionists would serve as an example. Still another direction, by juxtaposing more or less incongruous elements to create moods that have a poetic or dream-like reality, as in surrealist painting.

Along with the complaint of the unreality of much modern art is the complaint that so much of modern art is not beautiful. Beauty, like reality, is a phenomenon that people respond to on many different levels. If by beauty we mean that which pleases the senses, and the state of people's senses differ in degree of their development and refinement to the point where that which pleases one may repel another, then art is only indirectly concerned with beauty. For while the visual arts must necessarily make their appeal through the senses, when the work of art is meaningful it does more than pleasurably excite the senses, it speaks to the whole man, even to the point of inducing an exaltation which is a much more profound feeling than mere sensual pleasure. Perhaps this exaltation, this response of the spirit, could be called the ultimate beauty; and the response of the mind to the pleasurably sensual excitement through the eye, ear, or sense of touch, a lesser form of beauty. If you accept this definition of beauty, you could say that the purpose of art is beauty.

I would like to say one more thing about experiencing visual arts. Even if you come to them with the most sympathetic attitude, as is true of music, or love, or nature, to understand the deeper meaning of art requires contact over a period of time. Experiencing art is more than merely seeing it; you must enter into the mood of it, permit yourself to be moved by it. There should be a direct intuitive awareness of its form, an unconscious identification.

The need to express through art seems to be an innate part of man's nature, an aspect of the creativity of the human spirit.

The process of expressing through art is the crystallization of feeling into form, and the artist is a man who has an especial need, a stronger than ordinary need, to engage in this process, to crystallize his feelings into form.

Checklist

All measurements are in inches. For sculpture, height is followed by width followed by depth. For weavings and works on paper, height is followed by width unless otherwise indicated. For pottery (other than sculpture) height is followed by diameter of the vessel at the top rim. In addition, unless otherwise indicated, signatures are incised into the bottom of the ceramics; or on the bases of wood sculpture.

POTTERY

1. *Androcles and the Lion*, 1937
 Earthenware
 7 x 8 x 7; signed in ink: ScheieR 37
 Lent by Mary and Edwin Scheier

2. *The Square Dancers*, 1937
 Earthenware
 7 x 8 x 7; unsigned
 Lent by Mary and Edwin Scheier

3. *The Temptation of Adam and Eve*, 1937
 Earthenware
 8 x 12 x 8; signed: ScheieR
 Lent by Mary and Edwin Scheier

4. *The Ballet Dancer*, 1937
 Earthenware
 6¼ x 7¼ x 4¼; signed: Scheier
 Lent by Mary and Edwin Scheier

5. *Horse and Woman Rider with Pigs*, 1940–1945
 Earthenware
 14¼ x 10¾ x 7½; unsigned
 Lent by George and Ruth Wald

6. *Fear of The Bomb*, c. 1945
 Earthenware
 6¼ x 11¾ x 11¼; unsigned
 Lent by Mary and Edwin Scheier

7. *Bowl with figure design*, 1940
 Earthenware with sgraffito decoration
 5⅛ x 8⅛; signed: Scheier
 Lent by the Everson Museum of Art

8. *Vase with figure design*, c. 1940
 Earthenware with sgraffito decoration
 9¾ x 6⅛; signed: Scheier
 Lent by the Everson Museum of Art

9. *Vase*, c. 1940
 Earthenware
 8⅝ x 5³⁄₁₆; signed: Scheier
 Lent by John and Maryanna Hatch from
 the collection of Thelma Brackett

10. *Vase*, c. 1942
 Stoneware
 12 x 3; unsigned
 Lent by the University of New Hampshire
 Special Collections

11. *Bowl with figure design*, 1940
 Earthenware with low relief
 4¾ x 7½; unsigned
 Lent by the Everson Museum of Art

12. *Cider Jug with figure and apple design*, 1942
 Earthenware with low relief
 26 x 2; unsigned
 Lent by Flora Campbell

13. *Vase with bird, fish, deer and tree design*, c. 1942
 Earthenware with sgraffito decoration
 12 x 3; signed: ScheieR
 Lent by the University of New Hampshire
 Special Collections

14. *Vase with figure design*, mid-1950s
 Earthenware slab construction with
 sgraffito decoration
 8⅝ x 3⅞; unsigned
 Lent by The Currier Gallery of Art: Bequest of
 Isadore J. and Lucille Zimmerman

15. *Pitcher and Mug Set*, c. 1945
 Earthenware with sgraffito decoration
 Pitcher: 14 x 6; mugs: 3½ x 3⅛ (varies);
 signed: Scheier
 Lent by Shirley and Joe Cohen

16. *Coffee Pot with Cups and Saucers*,
 late 1940s – early 1950s
 Earthenware
 Coffee Pot: 15 x 8; cup and saucer: 3 x 4 (varies);
 signed: Scheier
 Lent by The Currier Gallery of Art: Gift of
 Mr. and Mrs. Charles Bacon

17. *Carafe with Cups*, late 1940s – early 1950s
 Earthenware
 Carafe: 12⅞, cups: 2⅜ x 2⅝ (varies);
 signed: carafe: Scheier, cups: S
 Lent by The Currier Gallery of Art: Gift of
 Mr. and Mrs. Charles Bacon

18. *Tea Service*, late 1940s – early 1950s
 Earthenware
 Teapot: 10 x 9; cup and saucer: 3 x 4 (varies);
 signed: teapot: Scheier, cups: S
 Lent by Fifty/50, New York, Mark Isaacson

19. *Covered Casserole*, 1944
Earthenware
6½ x 7⅜; signed: ScheieR
Lent by The Currier Gallery of Art:
Gift of Nancy Babcock

20. *Punchbowl and Cups*, early 1950s
Stoneware
Bowl: 7⅛ x 15⅛; cups: ⅜ x 3 (varies): signed:
bowl: Scheier; cups: S
Lent by Robert and Nancy Deane

21. *Platter*, late 1940s – early 1950s
Earthenware
1⅞ x 11¾; signed: ScheieR
Lent from the Collection of Philip E. Aarons

22. *Casserole*, late 1940s – early 1950s
Earthenware
3 x 16; signed: Scheier
Lent by Norman and Anne Milne

23. *Casserole*, early 1950s
Earthenware
3½ x 9¾; signed: Scheier
Lent by John and Maryanna Hatch from
the collection of Thelma Brackett

24. *Set of Dinnerware*, c. 1950
Stoneware
Plates: 1¼ x 9⅜ (varies); salad plates: ¾ x 6¾
(varies); saucers: ¾ x 6⅛ (varies); cups: 2½ x 3¾;
sugar: ¾ x 4¾; creamer: 3¾ x 5⅝; small bowls:
2 x 4⅞; teapot: 7 x 11; 2 serving bowls: 3¼ x 7⅜,
1¾ x 5¾; covered casserole: 5¾ x 14 (width);
signed: Scheier
Lent anonymously

25. *Set of Dinnerware*, c. 1950s
Stoneware
Plates: 1⅛ x 10½; salad plates: ⅞ x 8¾;
dessert plate: 1 x 6⅛; bowl: 2½ x 5½; bowl:
1½ x 4⅛; cup: 2½ x 3¾; saucer: ¾ x 5⅛;
wine cup: 2½ x 2¼; signed: Scheier
Lent by Joseph Mullen and Frank Howard

26. *Bowl*, 1950s
Stoneware
4 x 5¾; signed: Scheier S
Lent by The Currier Gallery of Art; Bequest of
Isadore J. and Lucille Zimmerman

27. *Bowl*, 1950s
Stoneware
3¾ x 5⅜; signed: Scheier
Lent by The Currier Gallery of Art: Bequest of
Isadore J. and Lucille Zimmerman

28. *Bowl*, 1950s
Stoneware
3¼ x 6¾; signed: Scheier X
Lent by The Currier Gallery of Art: Bequest of
Isadore J. and Lucille Zimmerman

29. *Bowl*, mid-1950s
Stoneware
3⅛ x 10⅛; signed: Scheier
Lent by George and Ruth Wald

30. *Bowl*, 1950s
Stoneware
4 x 6; signed: Scheier
Lent by David and Barbara Stahl

31. *Bowl*, late 1950s
Stoneware
4 x 6; signed: Scheier
Lent by David and Barbara Stahl

32. *Bowl*, late 1940s – early 1950s
Stoneware
2⅞ x 4³⁄₁₆; signed: Scheier Y
Lent by Gerry Williams

33. *Bowl*, late 1940s – early 1950s
Stoneware
3⅜ x 6⅝; signed: Scheier
Lent by Mary and Edwin Scheier

34. *Bowl*, late 1940s – early 1950s
Stoneware
1⁹⁄₁₆ x 3⅛; signed: Scheier 5
Lent by Gerry Williams

35. *Bowl*, early 1950s
Stoneware
3¾ x 6¼; signed: Scheier
Lent by Mary and Edwin Scheier

36. *Bowl*, late 1940s – early 1950s
Earthenware
2⁹⁄₁₆ x 3⅝; unsigned
Lent by Gerry Williams

37. *Vase*, 1950s
Stoneware
4 x 1; signed: Scheier
Lent by The Currier Gallery of Art: Bequest of
Isadore J. and Lucille Zimmerman

38. *Vase*, 1950s
Stoneware
4 x 1; signed: Scheier M V
Lent by The Currier Gallery of Art: Bequest of
Isadore J. and Lucille Zimmerman

39. *Vase*, 1950s
Stoneware
5⅜ x 1¾; signed: Scheier X
Lent by Joseph Mullen and Frank Howard

40. *Lamp*, c. 1950
Stoneware
Lamp: 14 x 3; shade: 6 x 10; signed: Scheier
Lent anonymously

41. *Vase*, 1956
Earthenware
3½ x 1; signed: ScheieR
Lent by Joseph Mullen and Frank Howard

42. *Bowl*, 1950s
Stoneware
2⅝ x 7½; signed: Scheier
Lent anonymously

43. *Bowl with abstract design*, late 1940s – early 1950s
Earthenware
7 x 16; signed: Scheier
Lent by Shirley and Joe Cohen

44. *Bowl with Figure Design*, 1951
Earthenware
11 x 17½; signed: ScheieR
Lent by The Currier Gallery of Art: Gift of
Isadore J. and Lucille Zimmerman

45. *Platter with figures*, 1958
Earthenware with low relief and sgraffito
decoration
1¾ x 19¼; signed in pencil: Scheier 1958
Lent by the League of New Hampshire
Craftsmen Foundation

46. *Platter with abstract design*, late 1940s
Earthenware
2⅝ x 19¾; signed: Scheier
Lent by the League of New Hampshire
Craftsmen Foundation

47. *Platter with The Temptation of Adam and Eve*,
late 1940s – early 1950s
Earthenware with sgraffito decoration
2 x 18; signed: ScheieR
Lent by Shirley and Joe Cohen

48. *Platter with three figures*, late 1940s – early 1950s
Earthenware with sgraffito decoration
2⅜ x 10⅜; signed: Scheier
Lent from the Collection of Philip E. Aarons

49. *Platter with the Temptation of Adam and Eve*,
c. 1948
Earthenware with sgraffito decoration
2¼ x 15½; signed: ScheieR
Lent anonymously

50. *Platter with the Temptation of Adam and Eve*,
1944
Earthenware with sgraffito decoration
2 x 18; signed: ScheieR 44
Lent by Mary and Edwin Scheier

51. *Platter with the Temptation of Adam and Eve*,
c. 1952
Earthenware with sgraffito decoration
1¾ x 15½; signed: Scheier
Lent by Detroit Institute of Art; Gift of
Mr. and Mrs. Sutter

52. *Platter with abstract figure design*,
late 1940s – early 1950s
Earthenware with sgraffito decoration
1⅞ x 17¼; signed: Scheier
Lent by Peter S. Brams

53. *Platter with Figures*, 1947
Earthenware with sgraffito decoration
1¾ x 12; signed: Scheier 47
Lent by The Currier Gallery of Art: Bequest of
Isadore J. and Lucille Zimmerman

54. *Platter with three figures and fish*,
late 1940s – early 1950s
Earthenware with sgraffito decoration
2¼ x 19⅝; signed: Scheier
Lent by Mr. and Mrs. Edward D. Eddy

55. *Platter with fish*, late 1940s – early 1950s
Earthenware with sgraffito decoration
1½ x 14½; signed: ScheieR
Lent by Robert and Nancy Deane

56. *Platter with two heads*, 1947
Earthenware with low relief decoration
2 x 15⅛; signed: ScheieR 47
Lent by Mrs. John A. Hogan

57. *Platter with abstract figure design*,
late 1940s – early 1950s
Earthenware with sgraffito decoration
2 x 19¾; unsigned
Lent by The League of New Hampshire
Craftsmen Foundation

58. *Platter with abstract figure design*,
late 1940s – early 1950s
Earthenware with low relief and sgraffito
decoration
2 x 18¹¹⁄₁₆; signed: Scheier
Lent from the Collection of The Art Gallery,
University of New Hampshire: David Campbell
Memorial Collection; Gift of Mr. and Mrs. Edwin
Scheier

59. *Platter with abstract head design*,
late 1940s – early 1950s
Earthenware with sgraffito decoration
1½ x 14⅞; signed: Scheier
Lent by George and Ruth Wald

60. *Platter with abstract design*, c. 1948
Earthenware with sgraffito decoration
2 x 14¼; signed: ScheieR
Lent anonymously

61. *Platter with abstract figure design*,
late 1940s – early 1950s
Earthenware with sgraffito decoration
2 x 15⅝; signed: ScheieR
Lent by the University of New Hampshire
Special Collections

62. *Bowl with abstract figure design*,
late 1940s – early 1950s
Earthenware with sgraffito decoration
11 x 15; signed: ScheieR
Lent by Marion E. James

63. *Vase with abstract design*, 1951
Earthenware with sgraffito decoration
23¼ x 6¼; signed: ScheieR 51
Lent by The Currier Gallery of Art: Bequest of
Isadore J. and Lucille Zimmerman

64. *Bowl with abstract design*, late 1940s
Earthenware with sgraffito decoration
5¾ x 6¾; signed: ScheieR
Lent by Mary and Edwin Scheier

65. *Vase with abstract design*, early 1950s
Earthenware with sgraffito decoration
9¾ x 3¼; signed: ScheieR
Lent by The Currier Gallery of Art: Bequest of
Isadore J. and Lucille Zimmerman

66. *Bowl with abstract design*, early 1950s
Stoneware with sgraffito decoration
5 x 7; signed: Scheier
Lent by Barbara and David Stahl

67. *Bowl with abstract design*, early 1950s
Stoneware with sgraffito decoration
5⅞ x 6⅝; signed: Scheier
Lent by The Currier Gallery of Art: Gift of
Charlotte Anderson

68. *God with Adam and Eve*, late 1940s – early 1950s
Thrown and modeled earthenware with
wooden base
32 x 8 x 6; unsigned
Lent by Mr. and Mrs. Mel Bobick

69. *Four Figures*, 1948
Thrown and modeled earthenware
23½ (varies); unsigned
Lent by Maria Carrier

70. *Covered Jar*, late 1940s – early 1950s
Earthenware with low relief, sgraffito and
modeled decoration
35½ x 4¼; unsigned
Lent by the League of New Hampshire
Craftsmen Foundation

71. *Covered Jar*, 1947
Earthenware with sgraffito and modeled
decoration
33½ x 3½; signed: ScheieR
Lent by George and Ruth Wald

72. *Jar*, late 1940s
Earthenware with modeled decoration
36 x 5; signed: ScheieR
Lent by Fifty/50, New York, Mark Isaacson

73. *Figure in God's Arms*, mid-1950s
Modeled earthenware
6 x 18 x 14; unsigned
Lent by Mr. and Mrs. Edward D. Eddy

74. *The Last Judgement*, 1946
Modeled earthenware
10½ x 18½ x 9½; signed in ink: Scheier 1946
Lent by Mary and Edwin Scheier

75. *Expulsion of Adam and Eve*, 1950s
Modeled earthenware
13¾ x 18 x 11; signed: Scheier
Lent by Mary and Edwin Scheier

76. *Sculpture with figures*, mid-1950s
Modeled earthenware
13 x 20¼ x 6; signed in ink: Scheier 55?
Lent by Mary and Edwin Scheier

77. *Temptation of Adam and Eve*,
late 1940s – mid 1950s
Modeled earthenware with slip decoration
34⅜ x 23 x 19½; unsigned
Lent by Mr. and Mrs. Edward D. Eddy

78. *The Punishment of Adam and Eve*, 1946
Modeled earthenware
10 x 12 x 9½; signed in ink: Scheier 1946
Lent by Mary and Edwin Scheier

79. *Sculpture with figures*, c. 1950
Modeled earthenware
44¼ x 6¼ x 6¼
Lent by the Estate of Albert W. Grokoest

80. *Jar with face design*, 1963
Stoneware with low relief decoration
18⅛ x 2⅜; signed: ´63´ Scheier
Lent by The Currier Gallery of Art: Bequest of
Isadore J. and Lucille Zimmerman

81. *Jar with multiple face design*, 1963
Stoneware with low relief
17¼ x 1¹⁵⁄₁₆; signed: 63 Scheier S
Lent from the Collection of Philip E. Aarons

82. *Covered Jar with figure design*, 1956
Earthenware with sgraffito and low relief decoration
15½ x 12¾; signed in pencil: Scheier
Lent by the American Craft Museum, New York; Museum Purchase, 1967/Donated to the American Craft Museum by the American Craft Council, 1990

83. *Covered Jar*, mid-1950s
Earthenware with sgraffito and low relief decoration
17¾ x 12¼; signed: Scheier
Lent by Mr. and Mrs. Edward D. Eddy

84. *Covered Jar*, mid-1950s
Earthenware
12 x 12; signed: Scheier
Lent by Barbara and David Stahl

85. *Bowl*, 1957
Earthenware with sgraffito decoration
10⅝ x 18; signed: Scheier
Lent by the Addison Gallery of American Art, Phillips Academy

86. *Bowl*, c. 1950
Earthenware
9 x 13¼; signed: Scheier
Lent by George and Ruth Wald

87. *Bowl with figure design*, mid-1950s
Earthenware with sgraffito decoration
12¾ x 11⅝; signed: Scheier
Lent by Dr. and Mrs. Richard Dranitzke

88. *Vase with figure design*, early 1950s
Earthenware with incised decoration
10 x 4; signed: SCHEIER
Lent by Mary and Edwin Scheier

89. *Vase with figure decoration*, mid-1950s
Earthenware with sgraffito and low relief decoration
12½ x 6⅜; signed: ScheieR
Lent by Peter S. Brams

90. *Vase with abstract design*, early 1960s
Stoneware with low relief decoration
20½ x 6⅜; unsigned
Lent by the University of New Hampshire Special Collections

91. *Vase with abstract design*, 1949
Stoneware with sgraffito and low relief decoration
13⅜ x 7; signed: ScheieR 49
Lent by The Currier Gallery of Art: Bequest of Isadore J. and Lucille Zimmerman

92. *Chalice*, c. 1960
Stoneware
6½ x 5⅝; unsigned
Lent anonymously

93. *Bowl with abstract figure design*, 1957
Earthenware with sgraffito decoration
16⅛ x 11; signed: Scheier
Lent by the American Craft Museum, New York; Museum Purchase, 1958/Donated to the American Craft Museum by the American Craft Council, 1990

94. *Chalice with abstract figure design*, c. 1960
Stoneware with sgraffito decoration
8½ x 5⅜; signed: Scheier
Lent by The Currier Gallery of Art: Bequest of Isadore J. and Lucille Zimmerman

95. *Bowl with figure design*, early 1950s
Earthenware with sgraffito decoration
5⅞ x 12¹¹⁄₁₆; signed: Scheier
Lent by Peter S. Brams

96. *Bowl with figure design*, early 1950s
Earthenware with sgraffito decoration
9¾ x 14¾; signed: Scheier
Lent from the Collection of Philip E. Aarons

97. *Bowl with abstract figure design*, early 1950s
Earthenware with sgraffito decoration
8 x 14; signed: ScheieR
Lent by Barbara and David Stahl

98. *Bowl with figure design*, mid-1950s
Stoneware with sgraffito decoration
4 x 10⅜; signed: Scheier
Lent by The Currier Gallery of Art: Bequest of Isadore J. and Lucille Zimmerman

99. *Bowl with figure design*, c. 1960
Stoneware with sgraffito decoration
4⅜ x 6½, signed: Scheier
Lent by Beatrice H. Achorn

100. *Vase*, 1945
Earthenware
13¾ x 6¾; signed: SCHEIER 45
Lent by Mrs. John A. Hogan

101. *Bowl with figure design*, mid-1950s
Stoneware
16 x 12; signed: Scheier
Lent by Elenore Freedman

102. *Vase with animal and figure design*, mid-1950s
Stoneware with sgraffito and low relief decoration
16⅜ x 6¼; signed: Scheier
Lent by Mr. and Mrs. Edward D. Eddy

103. *Vase with fish and figure design,* mid-1950s
Stoneware with sgraffito decoration
16⅞ x 5¼; signed: Scheier
Lent by Jean and Frank Kefferstan

104. *Vase with figure design,* 1962
Stoneware with sgraffito decoration
15 x 7½; signed: Scheier 62
Lent anonymously

105. *Vase with figure and face design,* 1964
Stoneware with sgraffito and low relief
decoration
23½ x 7; signed: ⸗64⸗ Scheier
Lent by the University of New Hampshire
Special Collections

106. *Vase with figure and face design,* 1964
Stoneware with sgraffito and low relief
decoration
23¼ x 8; signed: 64 Scheier
Lent by the University of New Hampshire
Museum

107. *Vase with figure design,* 1966
Stoneware with sgraffito and low relief
decoration
20⅜ x 5½; signed: Scheier ⸗66⸗
Lent by The Currier Gallery of Art: Bequest of
Isadore J. and Lucille Zimmerman

108. *Vase with figure design,* 1966
Stoneware with sgraffito and low relief
decoration
19 x 6⅜; signed: Scheier ⸗66⸗
Lent by The Currier Gallery of Art: Bequest of
Isadore J. and Lucille Zimmerman

109. *Vase with face design,* 1966
Stoneware with modeled and low relief
decoration
19 x 5¼; signed: Scheier ⸗66⸗
Lent by the University of New Hampshire
Special Collections

110. *Vase with face and figure design,* mid-1960s
Stoneware with modeled and low relief
decoration
22½ x 9¾; signed: Scheier
Lent by the University of New Hampshire
Special Collections

111. *Vase with face and figure design,* mid-1960s
Stoneware with sgraffito, low relief and modeled
decoration
16¼ x 11⅜ maximum width; signed: Scheier
Lent by the University of New Hampshire
Special Collections

112. *Platter with figures and animal,* 1991
Stoneware with sgraffito decoration
1¾ x 16¾; 91-Scheier
Lent by Mary and Edwin Scheier

113. *Platter with the Temptation of Adam
and Eve,* 1991
Stoneware with sgraffito decoration
1¾ x 15¾; signed: 91-Scheier
Lent by Mary and Edwin Scheier

114. *Platter with Adam and Eve and octopus,* 1991
Stoneware with sgraffito decoration
1¾ x 16¼; signed: 91-Scheier
Lent by Mary and Edwin Scheier

115. *Platter with man, woman, child, and lion,* 1991
Stoneware with sgraffito decoration
1¾ x 16⅜; signed: 91-Scheier
Lent by Mary and Edwin Scheier

116. *Platter with figure design,* 1991
Stoneware with sgraffito decoration
2 x 16⅝; signed: 91-Scheier
Lent by Mary and Edwin Scheier

117. *Platter with the Temptation of Adam
and Eve,* 1991
Stoneware with sgraffito decoration
1¾ x 15⅞; signed: 91-Scheier
Lent by Mary and Edwin Scheier

118. *Platter with the Temptation of Adam
and Eve,* 1991
Stoneware with sgraffito decoration
2 x 16¾; signed: 91-Scheier
Lent by Mary and Edwin Scheier

119. *Platter with the Temptation of Adam
and Eve,* 1991
Stoneware with sgraffito decoration
2 x 16¼; signed: 91-Scheier
Lent by Mary and Edwin Scheier

120. *Platter with the Temptation of Adam
and Eve,* 1991
Stoneware with sgraffito decoration
1¾ x 16¼; signed: 91-Scheier
Lent by Mary and Edwin Scheier

121. *Jar with figure and fish design,* 1992
Stoneware with sgraffito and low relief
decoration
13¼ x 11; signed: 92-Scheier
Lent by Mary and Edwin Scheier

122. *Bowl with figure design,* 1992
Stoneware with sgraffito decoration
8 x 15¾; signed: 92 Scheier
Lent by Fred and Valerie England

123. *Bowl with figure design,* 1992
Stoneware with sgraffito and modeled decoration
11 x 14⅞; signed: 92-Scheier
Lent by Mary and Edwin Scheier

124. *Covered Jar with figure design,* 1989
Stoneware with sgraffito, low relief and modeled
decoration
16¾ x 9¾; signed: 89 Scheier
Lent by Mary and Edwin Scheier

125. *Bowl with figure design,* 1991
Stoneware with sgraffito decoration
11¼ x 14¼; signed: 91-Scheier
Lent by Mary and Edwin Scheier

126. *Jar with figure design,* 1992
Stoneware with sgraffito, modeled and low
relief decoration
12⅞ x 10; signed: 92 Scheier
Lent by Mary and Edwin Scheier

127. *Bowl with figure and face design,* 1992
Stoneware with sgraffito, modeled and low relief
decoration
12⅞ x 13; signed: 92-Scheier
Lent by Mary and Edwin Scheier

128. *Bowl with figure design,* 1993
Stoneware with sgraffito, modeled and low
relief decoration
12 x 13; signed: Scheier
Lent by Mary and Edwin Scheier

129. *Jar with figure design,* 1992
Stoneware with sgraffito and modeled decoration
12¼ x 13; signed: 92-Scheier
Lent by Mary and Edwin Scheier

130. *Bowl with figure design,* 1992
Stoneware with sgraffito and modeled decoration
13¼ x 10⅞; signed: 92-Scheier
Lent by Mary and Edwin Scheier

131. *Bowl with figure design,* 1991
Stoneware with sgraffito and modeled decoration
11¾ x 13¾; signed: 91-Scheier
Lent by Mary and Edwin Scheier

132. *Bowl with figure design,* 1991
Stoneware with sgraffito and modeled decoration
11¼ x 14¼; signed: 91-Scheier
Lent by Mary and Edwin Scheier

133. *Covered Jar with figure design,* 1990
Stoneware with sgraffito and modeled decoration
18 x 10¾; signed: 90 Scheier
Lent by Mary and Edwin Scheier

134. *Bowl with figure design,* 1991
Stoneware with sgraffito and modeled decoration
13 x 10⅞; signed: 91 Scheier
Lent by Mary and Edwin Scheier

135. *Bowl with figure design,* 1991
Stoneware with sgraffito, modeled and low
relief decoration
12¾ x 11; signed: 91 Scheier
Lent by Mary and Edwin Scheier

136. *Bowl with figure design,* 1992
Stoneware with sgraffito and modeled decoration
7¼ x 15⅞; signed: 92-Scheier
Lent by Mary and Edwin Scheier

137. *Covered Jar with figure design,* 1990
Stoneware with sgraffito and modeled decoration
18 x 10; signed: Scheier 90
Lent by Mary and Edwin Scheier

138. *Jar with figure design,* 1992
Stoneware with sgraffito, modeled and low
relief decoration
11⅞ x 11¼; signed: 92-Scheier
Lent by Mary and Edwin Scheier

139. *Covered Jar with figure and face design,* 1993
Stoneware with sgraffito, modeled and low
relief decoration
18 x 12; signed: 93-Scheier
Lent by Mary and Edwin Scheier

140. *Covered Jar with figure design,* 1992
Stoneware with sgraffito, modeled and low
relief decoration
16½ x 9½; signed: 92-Scheier
Lent by Mary and Edwin Scheier

141. *Covered Jar with figure design,* 1990
Stoneware with sgraffito and modeled decoration
16¾ x 10¼; signed: 90 Scheier
Lent by the New Orleans Museum of Art:
Museum purchase in honor of Evelyn G.
Witherspoon

142. *Bowl with fish and figure design,* 1991
Stoneware with sgraffito, modeled and low
relief decoration
11 x 13¾; signed: 91-Scheier
Lent by Mary and Edwin Scheier

143. *Jar with figure design,* 1992
Stoneware with sgraffito, modeled and low
relief decoration
12½ x 11; signed: 92-Scheier
Lent by Mary and Edwin Scheier

144. *Jar with figure design,* 1992
Stoneware with sgraffito, modeled and low
relief decoration
13½ x 10¼; signed: 92 Scheier
Lent by Mary and Edwin Scheier

145. *Bowl with the Temptation of Adam and Eve,* 1993
Stoneware with sgraffito and modeled decoration
12½ x 12¼; signed: 93 Scheier
Lent by Mary and Edwin Scheier

146. *Bowl with figure and face design*, 1993
Stoneware with sgraffito, modeled and low
relief decoration
12¾ x 11¼; signed: 93 Scheier
Lent by Mary and Edwin Scheier

147. *Covered Jar with figure and face design*, 1993
Stoneware with sgraffito, modeled and low
relief decoration
12¾ x 8⅜; signed: 93·Scheier
Lent by Mary and Edwin Scheier

148. *Jar with figure design*, 1993
Stoneware with sgraffito, modeled and low
relief decoration
18¼ x 10¼; signed: 93 Scheier
Lent by Mary and Edwin Scheier

MIXED MEDIA

149. *Temptation of Adam and Eve with Lion*, 1967
Mixed media
16½ x 16; signed: Scheier 67
Lent by Mary and Edwin Scheier

150. *Family with Birds in Head*, 1981
Mixed media
19 x 14; signed on front: ES; on back: Scheier 81
Lent by Mary and Edwin Scheier

151. *Childbirth*, 1982
Mixed media
19 x 14; signed: Scheier 82
Lent by Stephane Janssen, Arizona

152. *Couple Embracing*, 1981
Mixed media
19 x 14; signed: Scheier 81
Lent by Mary and Edwin Scheier

153. *Mother and Child or Adam and Eve*, 1964
Mixed media
19 x 14; signed: Scheier
Lent by Dr. and Mrs. Richard Dranitzke

154. *Expulsion*, 1960
Pastel and ink
12 x 18; signed on back: Scheier 60
Lent by Mary and Edwin Scheier

155. *Childbirth*, 1981
Mixed media
19 x 14; signed on back: Scheier 81
Lent by Stephane Janssen, Arizona

156. *Man and Woman with Animal*, 1964
Mixed media
14 x 18 (image); signed on back: E. Scheier 1964
Durham N.H.
Lent by Mr. and Mrs. Edward D. Eddy

157. *The Gift of Fire*, 1976
Mixed media
18 x 14; signed: ES 76
Lent by Stephane Janssen, Arizona

158. *Childbirth*, 1978
Mixed media
14 x 18; signed: Scheier 78
Lent by Stephane Janssen, Arizona

159. *Fertility*, 1982
Mixed media
18 x 14; signed on back: Scheier 82
Lent by Mary and Edwin Scheier

WEAVINGS

160. *Temptation of Adam and Eve*, 1970
Wool
70 x 36; unsigned
Lent by Mr. and Mrs. Mel Bobick

161. *Figures and Fish*, 1968
Wool
36 x 60; unsigned
Lent by Mr. and Mrs. Mel Bobick

162. *Figures and Fish*, 1958
Wool
74 x 35; unsigned
Lent by Mary and Edwin Scheier

163. *Figures and Lions*, 1972
Wool
58 x 37; unsigned
Lent by Mary and Edwin Scheier

164. *Gift of Fire*, 1972
Wool
36 x 36; unsigned
Lent by Mary and Edwin Scheier

165. *Figures in a Whale*, 1976
Wool
37 x 48; signed: ES
Lent by Mary and Edwin Scheier

166. *Expulsion of Adam and Eve*, 1975
Wool
37 x 54; unsigned
Lent by Mary and Edwin Scheier

167. *Temptation of Adam and Eve*, 1972
Wool
48 x 48; signed: ES
Lent by Mary and Edwin Scheier

168. *Temptation of Adam and Eve*, 1972
Wool
70 x 38; signed: ES
Lent by Mary and Edwin Scheier

169. *Temptation of Adam and Eve*, 1958
Wool
48 x 48; unsigned
Lent by Robert and Nancy Deane

170. *Temptation of Adam and Eve*, 1975
Wool
57 x 37; signed: ES
Lent by Mary and Edwin Scheier

171. *Childbirth*, 1974
Wool
38 x 42; signed: ES
Lent by Mary and Edwin Scheier

172. *Man and Woman with Animal*, 1958
Wool
48 x 48; signed: ES
Lent by Mary and Edwin Scheier

173. *Figures inside Head*, 1958
Wool
48 x 48; unsigned
Lent by Mary and Edwin Scheier

SCULPTURE

174. *Childbirth*, 1968
Guanacastle wood and handmade jute rope
100 x 19 x 16; signed: Scheier 68
Lent by Mary and Edwin Scheier

175. *Childbirth*, 1973
Guanacastle wood, paint, nails and handmade
jute rope
60 x 18 x 10; signed: Scheier 73
Lent by Mary and Edwin Scheier

176. *Angel with Child*, 1968
Guanacastle wood and nails
61 x 36 x 14; signed: Scheier 68
Lent by Mary and Edwin Scheier

177. *Couple in Lion Mouth*, 1963
Painted guanacastle wood, nails, and crushed
marble
29 x 27½ x 6⅛; unsigned
Lent by Robert and Nancy Deane

178. *Fetish Figure*, 1955
Wood and nails
21½ x 12 x 9; unsigned
Lent by Mary and Edwin Scheier

179. *Animal with Figures*, 1971
Guanacastle wood and paint
16 x 32 x 18; signed: Scheier - 71
Lent by Mary and Edwin Scheier

180. *Childbirth*, 1971
Guanacastle wood and paint
44 x 32 x 12; signed: Scheier - 71
Lent by Mary and Edwin Scheier

181. *Mother and Child*, 1972
Guanacastle wood and handmade jute rope
44 x 19 x 16; signed: Scheier 1972
Lent by Mary and Edwin Scheier

182. *Couple with Spear and Shields*, 1970
Guanacastle wood and paint
44 x 14 x 14; unsigned
Lent by Chatham College

Special Note: Mary and Ed each signed works that were produced jointly, each with their own distinctive handwriting. A signature therefore is not the sole means of determining who made a specific work.

Frequently the Scheiers also marked pieces with a letter or numeral, such as x, y, or 5, for example. These marks refer to specific glaze formulas, and usually indicate that the piece in question was a prototype for that glaze.

Chronology

1908 May 9. Mary Skinker Goldsmith born in Salem, Virginia, the seventh child and youngest daughter in a family of nine children. Mary's mother Mira Livingston Hamersley was an accomplished musician and music teacher. Her father James Skinker Goldsmith was an express agent for the Norfolk and Western Railroad

1910 November 11. Edwin A. Scheier born in the Bronx, New York, the second of two children (with an older sister) to German-born parents Clara Bachert and Emmanuel Scheier. His father died shortly after Ed was born

1924 Mary Goldsmith graduates from Salem High School

1926 Goldsmith family moves to Christiansburg, Virginia

1926–29
Mary Goldsmith studies at Grand Central School of Art, Art Students League, and New York School of Fine and Applied Arts in New York

1930 Mary spends year in Paris in program of New York School of Fine and Applied Arts

1931 Mary works in advertising department of Burgoyne Hamilton Real Estate Agency in New York

1932 Mary returns to Christiansburg, Virginia, and works as stenographer

1935 Mary appointed director of Big Stone Gap and Abingdon Art Centers, the first Federal art galleries in Virginia. Organizes art classes for local schools

Ed Scheier attends classes at New York School of Industrial Arts

1937 Ed appointed to New York Federal Art Project. Develops and teaches courses in crafts, and develops traveling puppet show that he takes to various New York State Civilian Conservation Corps camps

Ed accepts position as coordinator for the Federal Recreation Project, develops programs in Louisiana, Mississippi, Alabama, and Tennessee

Ed made Field Supervisor of Federal Art Project in Kentucky, Virginia, and North Carolina

Ed gives three-day workshop at Frye Institute in Chattanooga, Tennessee, for instructors in Third district WPA recreational project; teaches puppetry and linoleum block printing

Ed advises on selection of and use of local clay for modeling and pottery in classes in Lynchburg and Big Stone Gap federal art galleries. Also organizes craft work in Breathitt County, Kentucky

August 19. Edwin Scheier and Mary Goldsmith married, and shortly after resign their positions to become puppeteers, traveling through the South.

Fall. Scheiers give puppet shows in Titusville and Tampa, Florida

1938 April. Ed made director of Anderson County Federal Art Center in Norris, Tennessee. Scheiers convert an old barn into workshop, and give puppet shows and teach puppet workshop at Norris Art Center. They teach courses in metal, wood, and leather, as well as drawing and painting

Scheiers begin experimenting with making pottery at Tennessee Valley Authority Ceramic Laboratory

Exhibition of paintings by living Apache, Navaho, Hopi, and Taos artists at Anderson County Federal Art Center, organized by WPA Federal Art Project in Washington

August. Scheiers set up pottery at Anderson County Federal Art Center. They make a wheel using parts from Ford Model T, and kiln from old oil drum

1939 Scheiers move to Glade Spring (Smyth County), Virginia to set up their first pottery, the Hillcrock Pottery. Mary makes small figural sculptures, some of which are sold in a New York shop. Ed makes small animal sculptures. Together they jointly produce functional pottery, including vases, mugs, pitchers. All work made using local clays

1940 Scheiers win second prize in pottery at *Ninth Annual Ceramic National Exhibition* at Syracuse Museum of Fine Arts (Syracuse, New York, now the Everson Museum of Art), their first submission to this juried show. Eight works acquired by the museum for its permanent collection. Their works accepted for and win prizes at almost every subsequent Ceramic National until 1958

Scheiers attend conference of the Art Division of The American Ceramic Society at Black Mountain, North Carolina

Scheiers invited to teach at University of New Hampshire by David R. Campbell, director of the League of New Hampshire Arts and Crafts. Ed appointed instructor in ceramics and pottery, and Mary artist-in-residence. With students they dig local clays for use in classes and in Scheiers' studio

Scheiers' work shown at The Metropolitan Museum of Art

1941 Summer. Scheiers exhibit work for the first time at annual fair of New Hampshire League of Arts and Crafts, where they will continue to show almost every year they remain in New Hampshire

Scheiers win Western Hemisphere ceramic prize for pottery at the *Tenth Annual Ceramic National Exhibition* at the Syracuse Museum of Fine Arts

1942 Ed joins Army Air Corps, serves as bombsight specialist in Denver, Colorado. Mary takes over Ed's courses at UNH

Scheiers win prize at *Eleventh Ceramic National Exhibition* at Syracuse Museum of Fine Arts. Work acquired by The Metropolitan Museum of Art

1943 Mary teaches course in puppetry for students in occupational therapy

October. Scheiers show work at Worcester (Massachusetts) Art Museum exhibition of *Contemporary New England Handicrafts* in a show that travels to several museums around the country

November. Exhibition of the Scheiers' work at The Currier Gallery of Art in Manchester, New Hampshire, the first of three major shows of their work at the Gallery.

1944 Show of Scheiers' work travels to Baltimore Museum of Fine Arts, Boston Museum of Arts and Crafts, Detroit Art Institute, Rochester Museum, Macy's in New York, and other museums

Ed released from Army Air Corps, returns to UNH

Works purchased by the Cincinnati Art Museum

1944–45
Mary appointed ceramics instructor at Rhode Island School of Design

Show of Scheiers' work at Museum of Art, Rhode Island School of Design

1945 Summer. Scheiers invited to teach ceramics in San Juan, Puerto Rico as part of an Operation Bootstrap development project for the Puerto Rico Industrial Development Company

1946 Works purchased by the Walker Art Center

1947 Scheiers win prize in *Twelfth Ceramic National Exhibition* at Syracuse Museum of Fine Arts

1948 April. Retrospective show of Scheiers' work at The Currier Gallery of Art

1949 Work by Scheiers acquired by International Museum of Ceramics in Faenza, Italy; The Cleveland Museum of Art; and the Virginia Museum of Fine Arts

1950 Scheiers' work acquired by Detroit Institute of Arts

October. Ed serves as juror for *Fifteenth Ceramic National Exhibition* at Syracuse Museum of Fine Art

1951 Scheiers move into a new home in Durham designed for them by architect David R. Campbell, director of the League of New Hampshire Arts and Crafts

November. Scheiers' work wins prize at *Sixteenth Ceramic National Exhibition* at Syracuse Museum of Fine Arts

1952 Scheier *Daniel Webster* platter included in "States and Territories" exhibition organized by the American Federation of Arts and sponsored by The Container Corporation of America

1953 Scheiers win grand prize at Brooklyn Museum of Art show. "Designer-Craftsmen USA – 1953," sponsored by American Craftsmen's Educational Council

Summer. Scheiers travel to Mexico, and work for archaeologist Franz Blom throughout southern Mexico to study Mayan sites

1955 April. Works by Scheiers given to President Dwight D. Eisenhower

June. Scheiers' work wins Medaille d'Argent at Cannes (France) International Exposition of Ceramics. Show travels to museums in Germany and Belgium

Scheiers' work included in show of contemporary art organized by the University of Illinois, Urbana, and which travels throughout the country under the auspices of the Smithsonian Institution Traveling Exhibition Service

1956 Scheiers receive medal from the Boston Society of Arts and Crafts

1957–58
On sabbatical, Scheiers travel to Mexico, spending five months in Oaxaca, where they become interested in the work of native Zapotec weavers. Ed designs weaving executed by local craftsmen and craftswomen

1959 First show of Ed's hangings at the Lamont Gallery at Phillips Exeter, Exeter, New Hampshire

October. Show of Scheiers' work at Society for Arts and Crafts, Boston

October. Ed serves as juror to National Crafts competition at the St. Paul (Minnesota) Gallery and School of Art

1960 Works purchased by Minnesota Museum of Art

Scheiers retire from University of New Hampshire, continuing to reside in Durham and spending four months during the winter in Mexico

1961 Scheiers spend several months in Italy, France, and Spain, living mostly in Mediterranean fishing village near Malaga, Spain. Unable to pot or sculpt due to lack of facilities, Ed does numerous oil paintings, his first attempt in that medium, and also makes drawings and prints

1962 Ed has show of mixed media works on paper

1963 Scheiers show work at New England Folk Festival in Boston

1964 September. Scheiers' work included in "Couples Crafters Show" at Worcester (Massachusetts) Craft Center

1965 May. Scheiers serve as jurors for "Indian Crafts '65" exhibition at Herron Museum of Art, Indianapolis

1966 May. Ed receives honorary Doctor of Humane Letters degree from University of New Hampshire

September. Major exhibition of Ed's work at The Currier Gallery of Art

December. Ed serves as juror of *Nineteenth Annual Ohio Ceramic and Sculpture Show* for The Butler Institute of American Art

1967 August. Ed serves as juror at forty-seventh annual exhibition of Wisconsin crafts at the Milwaukee Art Center

Works purchased by the Royal Ontario Museum, Toronto

1968 Scheiers move to Oaxaca, Mexico, building a home and studio where they would reside until 1978. Ed concentrates on wood sculptures, continues to design weavings, and makes paintings and prints

1973 Show of Ed's wood sculpture and weavings at Galeria Nabor Carrillo, Hamburgo, Mexico

1978 Scheiers return to United States, settling in Green Valley, Arizona. Ed once again begins to make pottery

1990 Scheiers made Honorary Fellows of the American Craft Council

1991 Scheiers made Honorary Members of the National Council for Education in Ceramic Arts

1992 April. Scheiers receive Charles Holmes Pettee Medal from University of New Hampshire

Selected Bibliography

This listing is compiled from the usual art historical reference sources, as well as from the Scheier Archive at The Currier Gallery of Art. This archive contains numerous original newspaper articles, magazine articles, and exhibition catalogues in which the Scheiers' work is included, mentioned, or illustrated. In order to follow the history of critical responses to the Scheiers' work, the bibliography is organized chronologically. In addition, exhibition catalogues listed in the following section are excluded.

"Puppet Show Wednesday," *Titusville Star-Advocate* (Titusville, Florida), November 30, 1937

"Empty Stocking Fund Gives Party for 4,000 Children Here Today," *The Tampa Daily Times* (Tampa, Florida), December 24, 1937

"Needy Given Christmas Joy," *The Tampa Daily Times* (Tampa, Florida), December 25, 1937

"New Art Center Director Man of Wide Experience," *The Courier* (Norris, Tennessee), April 1938 or later

Elise Torbet, "Mrs. Dripping Gold, Prof. Kookoo and Their Creators, Cause of Puppet Popularity among Residents at Norris," *The Knoxville News-Sentinel* (Knoxville, Tennessee), April 1938 or later

"Many Attend Classes at Norris Held by Director of County Art Center," *The Courier* (Norris, Tennessee), 1938

"Mrs. Peeps at the Art Center," *The Courier* (Norris, Tennessee), 1938

"At the Art Center," *The Courier* (Norris, Tennessee), 1938

"Dramatic Indian Paintings Shown at Art Center," *The Courier* (Norris, Tennessee), 1938

"Paintings Now at Art Center Are Proving Popular," *The Courier* (Norris, Tennessee), 1938

Elise Torbert, "Ancient Art of Pottery Making is Revived at Workshop at Norris with Potter's Wheel Made from Old T-Model," *The Knoxville News-Sentinel* (Knoxville, Tennessee), August 30, 1938

Jane Birchfield, "Clay Magic," *Richmond Times-Dispatch Magazine* (Richmond, Virginia), October 22, 1939: 6–7

Marian Eller, "Flat Tire Led to Founding of Smyth County Pottery Plant," *The Roanoke Times* (Roanoke, Virginia), November 26, 1939

Helen Park, "Flat Tire on Muddy Road Brings 'Luck' to Artists," *The Knoxville News-Sentinel* (Knoxville, Tennessee), January 1940

Elise Torbert, "Art Center's Sketching Class Draws From Life," *The Knoxville News-Sentinel* (Knoxville, Tennessee), August/September 1940

"In the All-American Ceramic Exhibition That Continues Through Nov. 3 at Syracuse Museum, Numerous Prizes Were Awarded to Both Sculpture and Pottery. Pictured Are Three of the Most Important Exhibits," *The Christian Science Monitor*, (Boston, Massachusetts), October 1940

Design, vol. 42 (December 1940): 7

"Art of the Pottery," *The Art Digest*, vol. 16, no. 3, (November 1, 1941): 12

"Interest in Pottery Making Grows at UNH," *The Union* (Manchester, New Hampshire), November 3, 1941

Eleanor Roberts, "Pottery Making New Art Field for Collegiates," *The Sunday Post* (Boston, Massachusetts), November 23, 1941

Design, vol. 43 (December 1941): 10

"Scheiers to Exhibit Pottery at UNH," *Portsmouth Herald* (Portsmouth, New Hampshire), March 29, 1943

"Edwin and Mary Scheier," *Bulletin of The American Ceramic Society – Ceramic History*, vol. 22, no. 8 (August 15, 1943): 263–270

"Contemporary New England Handicrafts," *Worcester Art Museum News Bulletin and Calendar*, vol. 9, no. 1 (October 1943)

"New England Promise," *House and Garden* (November 1943): 22–27

Art News, vol. 42 (November 1, 1943): 9

"Pottery Expert To Appear Here," *Worcester Gazette* (Worcester, Massachusetts), November 26, 1943

"Soon They'll Help Men on Way to Recovery," *New York Post* (New York, New York), November 26, 1943

"Punch and Judy Now Used in Rehabilitation of Casualties," *The Boston Post* (Boston, Massachusetts), November 26, 1943

"Puppets Aid New Course in Therapy," *The San Diego Union* (San Diego, California), November 28, 1943

"Punch and Judy Go to College," *Pioneer Press* (St. Paul, Minnesota), December 5, 1943

"A College 'Must' – Making Puppets," *Sun and Citizen-Leader* (Lowell, Massachusetts), December 9, 1943

"The War Brings Puppetry to Co-eds at the University of New Hampshire," *Washington Star* (Washington, DC), December 12, 1943

Design, (December 1943): cover and 12

"Scheier Pottery Goes on Tour," *The Christian Science Monitor* (Boston, Massachusetts), March 14, 1944

"Mary Scheier Finds Clay a Prize-Winning Medium for Her Art," *The Christian Science Monitor* (Boston, Massachusetts), May 2, 1944

Ruth Hunie Randall, "Exhibition of Ceramics," *Rhode Island School of Design Notes*, vol. 4 (January 1946): 3

Ruth Hunie Randall, "A Potter Looks at Scheier Pottery," *Design*, vol. 47 (January 1946): 17

"A Community Project Which Kept on Growing," *American Agriculturalist*, September 21, 1946

"Pottery Exhibition at Case Gallery," *Worcester Museum of Art Bulletin*, vol. 12 (November 1946): 6

"Scheier, Edwin," and "Scheier, Mary," *Who's Who in American Art 1940–1947* vol. 4 (Washington, DC: The American Federation of Art, 1947): 408; and subsequent years

"Pottery Making," *The Christian Science Monitor* (Boston, Massachusetts), June 27, 1947

"Artisans at N.H. Arts and Crafts Fair," *The Morning Union* (Manchester, New Hampshire), July 25, 1947

"Edwin Scheier. Potter," *Design*, vol. 49 (September 1947): 23

"Dates Set for 12th Annual National Ceramic Exhibition," *Ceramic Industry*, (August 1947)

Decorative Art. The Studio Year Book: 1943–1948 (London and New York: The Studio Publications, 1948): 100, 103, 109

"The Syracuse Museum…," *American Artist* (February 1948): 30–31

"Currier To Show Work of N.H. Potters," *The New Hampshire Sunday News* (Manchester, New Hampshire), April 11, 1948

"Scheier Pottery on View," *The Morning Union* (Manchester, New Hampshire), April 24, 1948

"Scheiers Honored at Tea," *Evening Leader* (Manchester, New Hampshire), May 13, 1948

"Yankee Teamwork," *Yankee* (October 1948): 68

Allan H. Eaton, *Handicrafts of New England* (New York: Harper & Brothers Publishers, 1949): 77, 158

Decorative Art. The Studio Year Book: 1949 (London and New York: The Studio Publications, 1949): 71, 74, 80

"Molded in Motion," *Boston Sunday Herald* (Boston, Massachusetts), March 6, 1949

"Will Show Potter's Art at Gilford Fair," *The Morning Union* (Manchester, New Hampshire), July 22, 1949

"Scheiers Take Prizes At Ceramic Exhibit," *The Morning Union* (Manchester, New Hampshire), November 1, 1949

Art Digest, vol. 24 (November 15, 1949): 11

Philbrook Paine, "Report From the Village: That Good Old Durham Clay," *The New Hampshire Sunday News* (Manchester, New Hampshire), November 20, 1949

Elizabeth Ray, "Ceramists Hope to Work Again With Virginia Clay," *The Times-Dispatch* (Richmond, Virginia), December 18, 1949

"UNH Ceramists Honored: Work To Be Shown at Faenza Museum," *The Morning Union* (Manchester, New Hampshire), February 24, 1949

"Two Pottery Bowls by Edwin and Mary Scheier," *Bulletin of The Detroit Institute of Arts*, vol. 29, no. 4 (1949–50): 96–98

Carnegie Magazine, vol. 24 (February 1950): 223

"Gilford Fair Potter Has Audience," *The Evening Leader* (Manchester, New Hampshire), August 5, 1950

Corey Black, "Foremost Ceramists to Have Exhibit Here," *The Washington Daily News* (Washington, DC), September 29, 1950

"Scheier Ceramics," *The Washington Star* (Washington, DC), October 1, 1950

"National Ceramic Exhibition Jury," *The Post-Standard* (Syracuse, New York), October 13, 1950

"N.H. Man on Ceramic Jury," *The Morning Union* (Manchester, New Hampshire), October 17, 1950

"Prizes Awarded to Winners Of Ceramic National Contest," *The Retailing Daily* (New York, New York), October 31, 1950

Decorative Art. The Studio Year Book: 1950–1951 (London and New York: The Studio Publications, 1951): 69, 77

Priscilla M. Porter, "Faenza," *Ceramics Monthly* (May 1951): 9–10

"The Pottery of Edwin and Mary Scheier," *American Artist*, vol. 15 (June 1951): 52

"New England Sculptors," *Yankee* (July 1951): 36

"McVey Wins Top Ceramics Award Second Time," *Syracuse Herald-American* (Syracuse, New York), November 4, 1951

"National Exhibition of Ceramics Opens November 16 at Museum," *Richmond Times-Dispatch* (Richmond, Virginia), November 11, 1951

Decorative Art. The Studio Year Book: 1951–1952 (London and New York: The Studio Publications, 1952): 91, 96

Robert Scharf, "Throwing on the Wheel," *Craft Horizons*, vol. 12 (May 1952): 14–18

"Designs Symbolic of States in Gallery Show," *New Hampshire Sunday News* (Manchester, New Hampshire), August 31, 1952

"Edwin and Mary Scheier. Notes by the Artists," *Everyday Art Quarterly* (Walker Art Center, Minneapolis, Minnesota), no. 27 (1953): 4–9

"Finest Work of Southern Craftsmen to be Judged at Virginia Art Museum," *Richmond Times-Dispatch* (Richmond, Virginia), May 24, 1953

Howard Derrickson, "Art and Artists. Craft Contest Tops July Shows," *St. Louis Post-Dispatch* (St. Louis, Missouri), July 5, 1953

Betty Pepis, "Crafts of the U.S.A.," *The New York Times Magazine* (New York, New York), October 18, 1953

"Designer Craftsmen U.S.A. 1953. Artists in the Crafts," *The New Hampshire Alumnus* (November 1953)

"The Shape of Things," *Glamour* (December 1953): 108 and 123

Paul Grigaut, "Edwin and Mary Scheier," *Everyday Art Quarterly* (Walker Art Center, Minneapolis, Minnesota), no. 27 (1953): 4–9

The Studio Year Book of Furnishings and Decoration 1953–1954 (London and New York: The Studio Publications, 1954): 95, 100, 111

The Studio Year Book of Furnishings and Decoration 1954–1955 (London and New York: The Studio Publications, 1955): 115

"Mrs. Mallen Receives Letter From President," *Foster's Daily Democrat* (Dover, New Hampshire), April 20, 1955

Craft Horizons, vol. 15 (September/October 1955): 15

The Studio Year Book of Furnishings and Decoration 1955–1956 (London and New York: The Studio Publications, 1956): 107

Edwin Scheier, "What is Art," *New Hampshire Alumnus* (March 1956)

Richard Petterson, "Ceramic Textures," *Craft Horizons*, vol. 16 (March/April 1956): 24-27

Philbrook Paine, "How to Live in Rural NH Without Farming. State a Haven for Many Craftsmen," *New Hampshire Sunday News* (Manchester, New Hampshire), July 29, 1956

Louise Androvette, "Perfection in Pottery," *New Hampshire Profiles*, (December 1956)

The Studio Year Book of Furnishings and Decoration 1956-1957 (London and New York: The Studio Publications, 1957): 91, 95

"Museum Exhibit To Feature Paintings, Ceramics, Textiles," *Fitchburg Sentinel* (Fitchburg, Massachusetts), April 4, 1957

"400 Attend Museum Exhibit Of Oils, Ceramics, Weaving," *Fitchburg Sentinel* (Fitchburg, Massachusetts), April 8, 1957

Asilomar. An Exhibition and Condensation of Proceedings from the First Annual Conference of American Craftsmen, Sponsored by the American Craftsmen's Council. June, 1957: 167

Design Quarterly (Walker Art Center, Minneapolis, Minnesota), nos. 42 and 43 (1958). Unpaginated

Ruth S. Wilkins, "The Ceramic National Exhibitions," *A Ceramics Monthly Portfolio* (Everson Museum of Art, Syracuse, New York, 1958). Unpaginated

The Studio Year Book of Furnishings and Decoration 1958–1959 (London and New York: The Studio Publications, 1959): 107, 115

The Metropolitan Museum of Art Bulletin, vol. 17 (February 1959): 162

"International Ceramic Show," *New York Herald Tribune* (New York, New York), July 20, 1959

"Ceramic Craftsmanship of the Scheiers," *The Christian Science Monitor* (Boston, Massachusetts), October 2, 1959

"Exhibitions of Rugs and Ceramics," *Craft Horizons*, vol. 19 (November 1959): 41

"A New Scheier Medium," *New Hampshire Alumnus* (December 1959): 12–13

Josephine D. Gilman, "World-Famous Ceramists," *Worcester Sunday Telegram* (Worcester, Massachusetts), August 19, 1962

"Center Opens 'Couple Crafters' Show," *Worcester Daily Telegram* (Worcester, Massachusetts), September 17, 1964

"Edwin Scheier. Durham Potter's Work Put In National Art Exhibit," *Foster's Daily Democrat* (Dover, New Hampshire), May 25, 1966

"Currier Gallery Exhibiting Works of Artist-Craftsman," *The Evening Union Leader* (Manchester, New Hampshire), September 30, 1966

"Ceramactivities," *Ceramics Monthly* (October 1966): 32

"Edwin Scheier Works on View at Currier," *The New Hampshire Sunday News* (Manchester, New Hampshire), October 2, 1966

Ellen Eppelsheimer, "The New Hampshire Art Scene," *Concord Monitor* (Concord, New Hampshire), October 14, 1966

"Artist to Discuss Work at Currier," *The Evening Union Leader* (Manchester, New Hampshire), October 26, 1966

"Edwin Scheier," *Craft Horizons* (November/December 1966)

Polly Rothenberg, "Edwin and Mary Scheier," *Ceramics Monthly*, vol. 15, no. 1 (January 1967): 12–18

"1967 Ohio Ceramic and Sculpture Show," *Youngstown Vindicator* (January 29, 1967)

"Craft Judge," *Milwaukee Journal* (Milwaukee, Wisconsin), August 19, 1967

"Durham Couple To Exhibit at Exeter," *Manchester Union Leader* (Manchester, New Hampshire), June 5, 1968

Jeanette Jena, "Spirit of Primitive Man Marks Scheier Exhibit," *The Post-Gazette* (Pittsburgh, Pennsylvania), April 1970

Polly Rothenberg, *The Complete Book of Ceramic Art* (New York: Crown Publishers, Inc., 1972): 5, 79, 107, 130, 131, 146, 163, 202, 236

"Change at Chatham: New Buildings and Patterns," *Chatham College Bulletin*, vol. 49, no. 3 (September 1973)

"Alegoria, Forma y Fantasia," *Revista Mexicana de Cultura* (Mexico City, Mexico), November 11, 1973

Elaine Levin, "Pioneers of Contemporary American Ceramics: Laura Andreson, Edwin and Mary Scheier," *Ceramics Monthly*, vol. 24, no. 3 (May 1976): 30–36

"Tubac showing GV potter's art," *Green Valley News* (Green Valley, Arizona), February 22, 1978

Margaret McBride, "Famed Green Valley Artist Shows Talents at Tubac," *Nogales International* (Nogales, Mexico), March 1, 1978

Garth Clark and Margie Hughto, *A Century of Ceramics in the United States* (New York: E.P. Dutton in association with Everson Museum of Art, 1979): 115, 125, 325

Kathie Beals, "Local gift store sets '79 Art Craft Festival," *Westchester Weekend* (Westchester, New York), November 16, 1979

"Eight Days a Week" section, *Tucson Weekly* (Tucson, Arizona), December 22–30, 1980

Richard Zakin, *Electric Kiln Ceramics: A Potter's Guide to Clays and Glazes* (Radnor, Pennsylvania: Chilton Book Company, 1981): 188–190

Dale Parris, "Sculptor, potter weaver. Edwin Scheier: A master of his art," *Green Valley News/Sun* (Green Valley, Arizona), January 4, 1981

Carol Sowell, "Green Valley Artists Not the Retiring Type," *The Arizona Daily Star* (Tucson, Arizona), January 16, 1981

Edward Lebow, "A Sense of Line," *American Craft*, vol. 48 (February/March 1988): 24–31

Barbara Perry, editor, *American Ceramics: The Collection of Everson Museum of Art* (New York: Rizzoli International Publications, Inc., 1989): 122, 125, catalogue numbers 178–180, 337

Garth Clark, *American Ceramics, 1876 to the Present* (New York: Abbeville Press, 1989): 88, 297, 322

Robert Silberman, "The First Moderns," *American Craft*, vol. 49, no. 1 (February/March 1989): 46–53, 71

Richard Nilsen, "Art with Attitude," *Arizona Republic* (Phoenix, Arizona), May 2, 1991

"Arts Now Showing," Tucson Guide Quarterly, (Fall 1991): 121

"20th Century Art Pottery," *Kovels on Antiques and Collectibles*, vol. 18, no. 4 (December 1991): 43

"Arts & Crafts at Auction," *Art Today*, vol. 1/2 (1992): 30

"UNH Library Showcases Selection of Ceramic Art," *Manchester Union Leader* (Manchester, New Hampshire), April 23, 1992

Deidre Waz, "Ceramics Collectors Shift Focus to Works of the Smaller Studios," *MassBay Antiques* (June 1992): 3–4 and 19

Selected Exhibitions

1940 *The Ninth Annual Ceramic National Exhibition, Syracuse Museum of Fine Arts* (Syracuse, New York), October 13 – November 3. Catalogue numbers 345–348. Awarded $100 Hanovia Chemical Company purchase prize

1941 *Contemporary Ceramics of The Western Hemisphere*, Syracuse Museum of Fine Arts (Syracuse, New York), October 19 – November 16. Catalogue numbers 350–354. Awarded $100 Onondaga Pottery Company prize

1943 Untitled show of pottery by Mary and Edwin Scheier, Concord Public Library (Concord, New Hampshire), April. No catalogue

Contemporary New England Handicrafts, Worcester Art Museum, (Worcester, Massachusetts), October 14 – December 26. Unpaginated catalogue without checklist

Pottery by Mr. and Mrs. Edwin Scheier, The Currier Gallery of Art (Manchester, New Hampshire), November. No catalogue

1944 Untitled exhibition of pottery by Mary and Edwin Scheier, and metalwork by Karl Drerup, Hamilton Smith Library, University of New Hampshire (Durham, New Hampshire), January. No catalogue

1946 *Eleventh Annual Ceramic National Exhibition*, Syracuse Museum of Fine Arts (Syracuse, New York), November 3 – December 15, catalogue numbers 374–378. Awarded $100 Onondaga Pottery Company prize

1947 *Exhibition of Pottery by Mary and Edwin Scheier of Durham, New Hampshire*, Museum of Art, Rhode Island School of Design (Providence, Rhode Island), January 8 – January 27, 1946

Twelfth Annual Ceramic National Exhibition, Syracuse Museum of Fine Arts (Syracuse, New York), November 9 – December 7. Catalogue numbers 178–181. Awarded one-fourth of $500 Richard B. Gump prize

1948 *Pottery by Edwin and Mary Scheier*, The Currier Gallery of Art (Manchester, New Hampshire), April 15 – May 15. No catalogue

Thirteenth Annual Ceramic National Exhibition, Syracuse Museum of Fine Arts (Syracuse, New York), November 7 – December 12. Catalogue numbers 181–182. Honorable mention for pottery

1949 *Fourteenth Annual Ceramic National Exhibition*, Syracuse Museum of Fine Arts (Syracuse, New York), October 30 – December 4. Catalogue numbers 387–392. Awarded $100 Onondaga Pottery Company prize, half of $500 Richard B. Gump prize, and honorable mention for pottery

1950 *Fifteenth Annual Ceramic National Exhibition*, Syracuse Museum of Fine Arts (Syracuse, New York), October 29 – December 3. Catalogue numbers 376–379. Awarded half of $500 Richard B. Gump prize and $100 Onondaga Pottery Company prize

Ceramics by Mary and Edwin Scheier, Ursell's (Washington, D.C.), October 1 – October 21. No catalogue

1951 *Third Biennial Exhibition of Textiles and Ceramics*, Museum of the Cranbrook Academy of Art (Bloomfield Hills, Michigan), March 3 – March 25. Catalogue numbers 88–90

New England Sculptors, Addison Gallery of American Art, Phillips Academy (Andover, Massachusetts), March 30 – April 30; and Wadsworth Atheneum (Hartford, Connecticut), May 5 – June 3. Checklist number 50 (work by Edwin Scheier)

Thirty-Four American Artists, The University Gallery, University of Minnesota (St. Paul, Minnesota), June 4 – August 30. Unpaginated catalogue with unnumbered checklist

Sixteenth Ceramic National, Syracuse Museum of Fine Arts (Syracuse, New York), November 4 – December 2. Catalogue numbers 388–395. Awarded $100 Onondaga Pottery Company prize

1953 *Designer Craftsmen U.S.A. 1953*, The Brooklyn Museum (Brooklyn, New York) and the American Craftsmen's Educational Council, September. Catalogue numbers 62–63

1955 *New England Craft Exhibition*, Worcester Art Museum (Worcester, Massachusetts), October 12 – November 27. Catalogue numbers 143–154

Twelfth Annual Invitational Exhibition of Ceramic Art, Scripps College (Pomona, California), March 15 – April 15. Unpaginated catalogue without checklist

1956 *Craftsmanship in a Changing World*, Museum of Contemporary Crafts (New York, New York), September 20 – November 4. Exhibition circulated by The American Federation of Arts. Catalogue numbers 232–234

1957 *Variations in Media*, The Museum of Contemporary Crafts (New York, New York), May 17 – June 23. No catalogue

1958 *Twentieth Ceramic National*, Syracuse Museum of Fine Art (Syracuse, New York), October 26 – December 7. Catalogue numbers 457–460. Awarded half of $200 United States Potters Association prize

1959 *Edwin and Mary Scheier*, The Society of Arts and Crafts (Boston, Massachusetts), May 13 – June 3. No catalogue

1961 *Masters of Contemporary American Crafts*, The Brooklyn Museum (Brooklyn, New York), 1961. Unpaginated

1962 *Contemporary Crafts of the United States*, Skidmore College (Saratoga Springs, New York), April 11 – May 1. Catalogue number 38.1–4

1963 *Clay Today, The New Gallery*, State University of Iowa, December 4, 1962 – January 8, 1963. Pages 14–15, catalogue numbers 1–5 and illustration section, page 18

1964 *Couple Crafters Show*, Worcester Craft Center (Worcester, Massachusetts), September 16 – October 16, 1964. No catalogue

1966 *Edwin Scheier, The Currier Gallery of Art* (Manchester, New Hampshire), September 30 – October 30; and Hopkins Center Art Galleries, Dartmouth College (Hanover, New Hampshire), November 5 – November 27. Unpaginated without checklist, published as an issue of *The Currier Gallery of Art Bulletin*

1970 *An Exhibition by Edwin & Mary Scheier*, Chatham College Chapel Lounge (Pittsburgh, Pennsylvania), April 12 – April 30. No catalogue

1973 *Edwin Scheier*, Galeria Nabor Carrillo, Instituto Mexicano Norteamericano de Relaciones Culturales (Hamburgo, Mexico), October 11 – December 31. Unpaginated catalogue without checklist

1974 *Edwin Scheier*, Alianza Francesa de Oaxaca (Oaxaca, Mexico), March 11 – March 30. Unpaginated catalogue without checklist

1980 *Genesis: Edwin Scheier*, University of Arizona Museum of Art (Tucson, Arizona), December 6, 1980 – January 18, 1981. Unpaginated brochure with numbered checklist

1981 *Edwin Scheier*, The Lambert Miller Gallery (Phoenix, Arizona), October 18 – November 14. Unpaginated brochure without checklist

1982 *Scheier. Pottery, Painting, Sculpture, Weavings*, Fifty 50 Gallery (New York, New York), October 8 – October 31. Unpaginated catalogue without checklist

1984 *Edwin Scheier: Sculpture, Painting, Weaving, Pottery*, Tubac Center of the Arts (Tubac, Arizona), January 6 – February 5. Unpaginated brochure without checklist

1985 *Asian Reflections. Contemporary Ceramists Consider the East*, Helen Wells Decorative Arts Gallery (Phoenix, Arizona), July 23 – October 27. Unpaginated brochure with unnumbered checklist

1986 *Abstract Expressionism and American Decorative Arts*, University Art Museum, University of Minnesota (Minneapolis, Minnesota), October 12 – December 7. Catalogue numbers 19–23

1987 *Edwin Scheier and Wayne Bates*, Craft Alliance Gallery (St. Louis, Missouri), October 5 – October 25. No catalogue

1988 *American Studio Ceramics: 1920–1950*, University Art Museum, University of Minnesota (Minneapolis), November 10, 1988 – January 8, 1989. Exhibition circulated by The American Federation of Arts. Catalogue numbers 43–52

1990 *Edwin Scheier*, Art Start Gallery (Scottsdale, Arizona), January 3 – January 31. Unpaginated brochure without checklist

1993 *Past and Present: Ongoing Traditions in American Craft Art*, The Mitchell Museum (Carbondale, Illinois), February 13 – April 14, 1993

Museum Collections

Addison Gallery of American Art
American Craft Museum
Arizona State University Art Museum
The Art Gallery, University of New Hampshire
The Art Institute of Chicago
The Brooklyn Museum
Butler Institute of American Art
The Carnegie Museum of Art
Chatham College Gallery
Cincinnati Art Museum
Cleveland Museum of Art
Columbus Museum of Art
Cooper Hewitt Museum
Cranbrook Academy of Art Museum
Crocker Art Museum
The Currier Gallery of Art
The Detroit Institute of Art
Everson Museum of Art
High Museum of Art
Honolulu Academy of Arts
Krannert Art Museum
The Lamont Gallery, Phillips Exeter Academy
Landesgewerbeamt, Stuttgart, Germany
The League of New Hampshire Craftsmen
 Foundation
The Metropolitan Museum of Art
Minnesota Museum of Art
Museum of Fine Arts, Boston
Museum of International Ceramics, Faenza, Italy
Museum of Art, Rhode Island School of Design
The Nelson-Atkins Museum of Art
The Newark Museum
New Orleans Museum of Art
Northwestern Oklahoma State University Museum
Philadelphia Museum of Art
Rochester Art Center

Royal Museum, Mexico
Royal Ontario Museum of Art, Ontario, Canada
The Slater Memorial Museum
Smithsonian Institution
J. B. Speed Art Museum
Syracuse University Art Collection
Tokyo Museum, Japan
University of Arizona Museum of Art
University Art Museum, Minnesota
University of Nebraska State Museum
University of New Hampshire Museum
University of New Hampshire Special Collections
University of Wisconsin-Milwaukee, Union Art
 Gallery
Virginia Museum of Art
Walker Art Museum
Waterloo Museum of Art
Yale University Art Gallery

PHOTOGRAPHY

Photographs of objects in the exhibition were taken by Bill Finney, except: cat. 51 © Detroit Institute of Arts, and cat. 7, 8, 11 by Courtney Frisse.

Unless otherwise indicated, all other photographs are from the Scheier Archives at The Currier Gallery of Art.

AMERICAN POTTERS: *Mary and Edwin Scheier*

This catalogue was designed by Gilbert Design Associates and printed by Meridian Printing on Gleneagle paper. The typeface is Kennerley, designed in 1911 by Frederic Goudy. Two thousand softcover copies for The Currier Gallery of Art, Manchester, New Hampshire on the occasion of the exhibition. September MCMXCIII.